900
g8

as is—
small tear
on
front

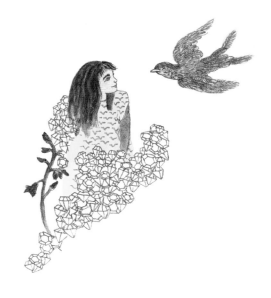

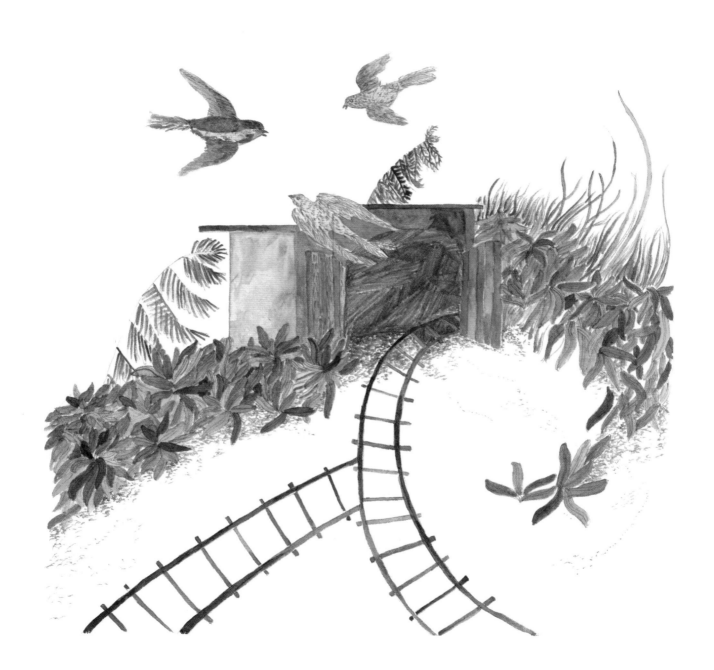

The LITTLEST BIRDS SING THE PRETTIEST SONGS

FOLK MUSIC ILLUSTRATED BY

JENNIE SMITH

INTRODUCTION BY MICHAEL HURLEY

CHRONICLE BOOKS

SAN FRANCISCO

Library of Congress Cataloging-in-Publication Data available.

ISBN: 978-0-8118-7509-7

Manufactured in China.

Design by Jennifer Tolo Pierce and Brooke Johnson.

"The Animal Song" by Michael Hurley used by permission of the artist.

"Cave" by Breathe Owl Breathe used by permission of the artist.

"The Littlest Birds" by Samantha Parton and Jolie Holland used by
permission of Nettwerk Songs Publishing Limited.

"Light Green Leaves" by Little Wings used by permission of the artist.

"Home By The Sea." Words and Music by A.P. Carter. Copyright © 1929
by Peer International Corporation. Copyright Renewed. International
Copyright Secured All Rights Reserved. *Reprinted by Permission of Hal
Leonard Corporation.*

"Winter's Come And Gone." Words and Music by Gillian Welch and David
Rawlings. Copyright © 1998 IRVING MUSIC, INC., SAY UNCLE MUSIC
and CRACKLIN' MUSIC. All Rights for SAY UNCLE MUSIC Controlled and
Administered by IRVING MUSIC, INC. All Rights for CRACKLIN' MUSIC
Controlled and Administered by BUG MUSIC. All Rights Reserved. Used
by Permission. *Reprinted by Permission of Hal Leonard Corporation.*

10 9 8 7 6 5 4 3 2 1

Chronicle Books LLC
680 Second Street
San Francisco, CA 94107

www.chroniclebooks.com

INTRODUCTION

The first stories that we hear as children are so very simple, yet to a beginner at the practice of contemplation their territory is as vast as all of creation. A process begins even before one has learned to read. It is the hearing of a story in the language one has just learned to understand and it is the seeing of a picture that one can recognize to be of the world one has come to know. It is the finding of an action that alerts and impresses and may be remembered throughout one's lifetime. And from there it can be all the imagination can contain.

And now the animals and plants of the land, air, and water may be remote from the visions of a child when mankind constructs a world all around us of synthetic materials. So it is good to document the frog and the hill, the birds and the stars, the motivated actions of the people and creatures of the earth. We certainly see them in this book of folk songs.

I wish I was a mole in the ground.

She proved fickle and turned her back. And ever since then I've dressed in black.

If we didn't know what a frog looked like, or even a rat, still we might see their images as with some of the first beasts etched on a cave wall, now extinct, and might still know the heart of humankind, the love songs, the deeds good and bad. When it's all gone away, what is here to stay? I don't know. I'm going out to play. OK.

Michael Hurley
Astoria, Oregon, Spring 2011

ARTIST'S STATEMENT

From traditional Scottish ballads to the folk songs of today, song writers have always been inspired by the natural world. Whether depicting the beauty of a spring day while out with a lover or comparing the darkness of winter to one's personal anguish and struggles, it is to nature we turn to describe our inner selves. No matter what time period we find ourselves living in, our human instinct is to seek solace in the oceans, forests, deserts, and other landscapes of the world.

Nearly every living thing makes music—a whistle from a man, a chirp from a grasshopper, the sway of a branch in the wind. My inherent love of nature and its vibrant inhabitants has served as the source of inspiration for my drawings. I often find myself listening to folk music while drawing and one day came up with the idea to illustrate the classic ballad, "And the Green Grass Grows All Around." It was with that song that this project began. I discovered that the story I heard in this song, as well as many others, naturally lent themselves to visual interpretations.

Most of the songs I selected have been special to me at one time or another. The Carter Family, a group that has had a profound influence on bluegrass, country, southern gospel, and other forms of American roots music, was the first country music I heard as a child. Most likely it was their famous "Keep on the Sunny Side" that captivated me then. For this project, I chose their "Home by the Sea," a gorgeous ballad about the yearning to return to a place that may no longer exist, by the beloved seashore.

As the book includes many songs from days long past, I decided to also bring in a few songs from musicians I listen to today. Gillian Welch, who often performs with her collaborator David Rawlings, has a rich voice that feels rooted in the past traditions of Appalachian and American Blues and, at the same time, contemporary.

The collection features thirteen songs written and performed by an array of artists that share one common thread—turning to nature as a source of inspiration, a metaphor for human feelings, or honoring its mysteries. Following in the tradition of handing down stories and songs, I'd like to pass these drawings on to you.

Jennie Smith
San Francisco, Summer 2011

"HEMLOCKS AND PRIMROSES"

by Landon Messer and Ralph Stanley

Thinking of you while out for a ramble
Down by a cold frosty stream
Set down on a bed of hemlocks and primroses
Gently I fell into a dream

I dreamed I saw a fair maiden
Such beauty I had never seen
Her dress was bound round with hemlocks
and primroses
So green was the mantel she wore

Her hair was of a dark brown color
Her teeth was ivory so white
Her eyes they shined like diamonds
Of stars that shine on a cold frosty night

I drew her near then I awakened
With two empty arms and you on my mind
Heaven seemed so near when I was dreaming
It hurts to know you left me behind

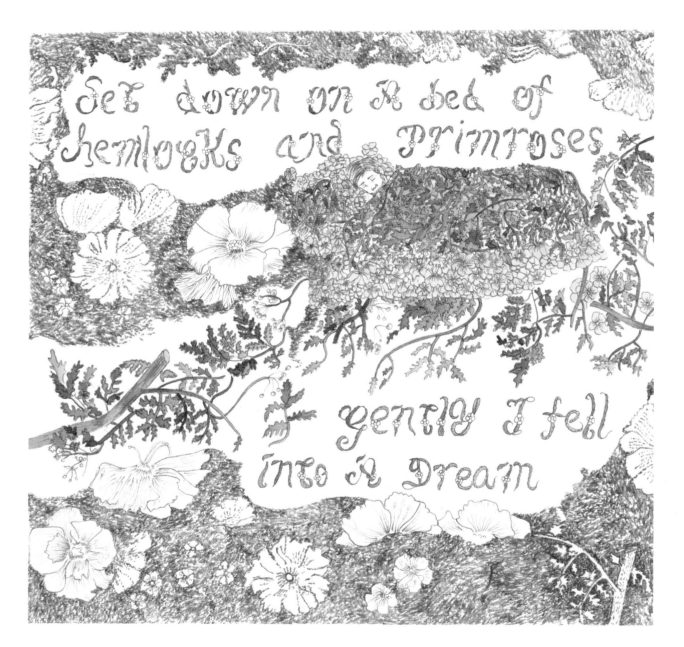

set down on a bed of hemlocks and primroses gently I fell into a dream

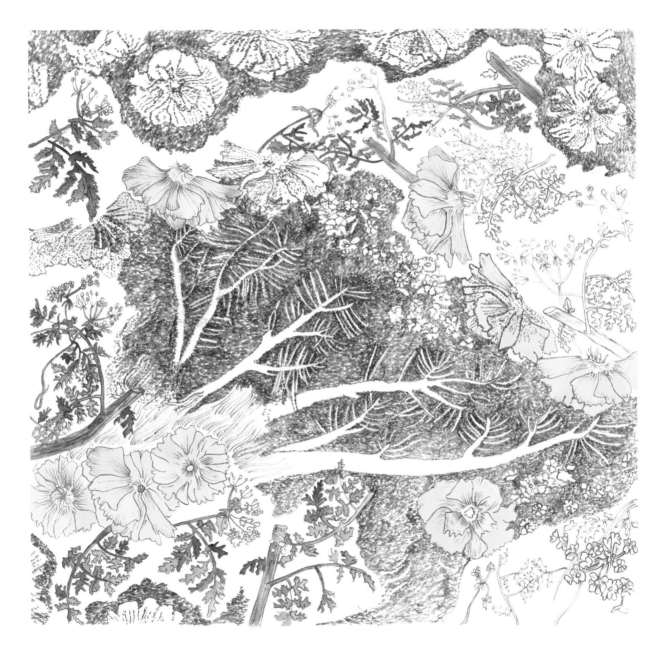

I dreamed
I saw a
fair
maiden

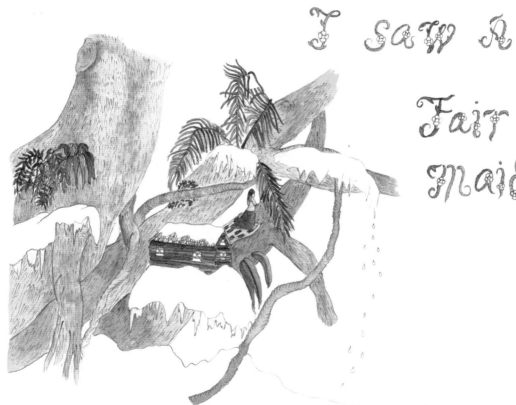

Such beauty
I'd never seen

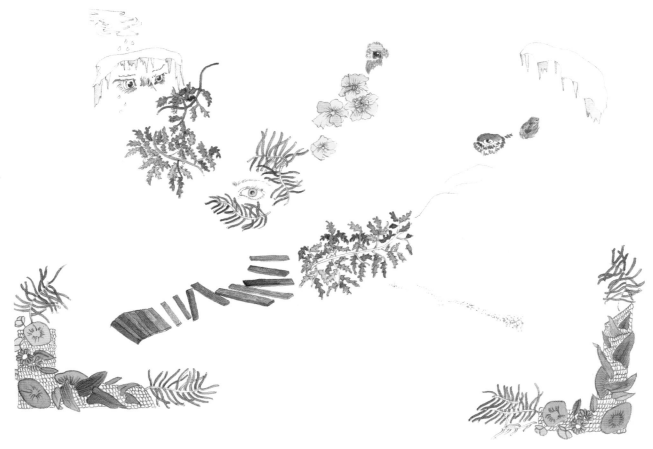

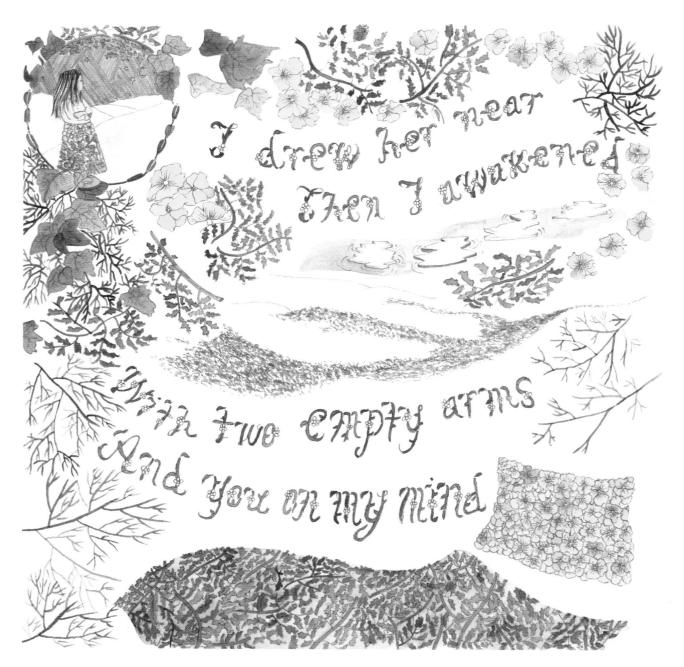

I drew her near
then I awakened

with two empty arms
And you on my mind

Heaven seemed
so near when I was dreaming

It hurts to
know you left
Me behind

Hemlocks and Primroses
Landon Messer & Ralph Stanley

```
A    D E A
            A
Thinking of you while out for a ramble
       D E        A
Down by a cold frosty stream
              A
Set down on a bed of hemlocks and primroses
         DE
Gently I fell into a dream
              A                        D     E
I dreamed I saw a fair maiden, such beauty I had never seen
                    A
Her dress was bound round with hemlocks and primroses
       D  E            A
So green was the mantel she wore
            A                              D E
Her hair was of a dark brown color, her teeth was ivory so white
            A
Her eyes, they shined like diamonds
         D  E            A
Of stars that shine on a cold frosty night
            A
I drew her near then I awakened
            D  E              A
With two empty arms and you on my mind
                 A
Heaven seemed so near when I was dreaming
        D  E           A
It hurts to know you left me behind.
```

"THE ANIMAL SONG"

by Michael Hurley

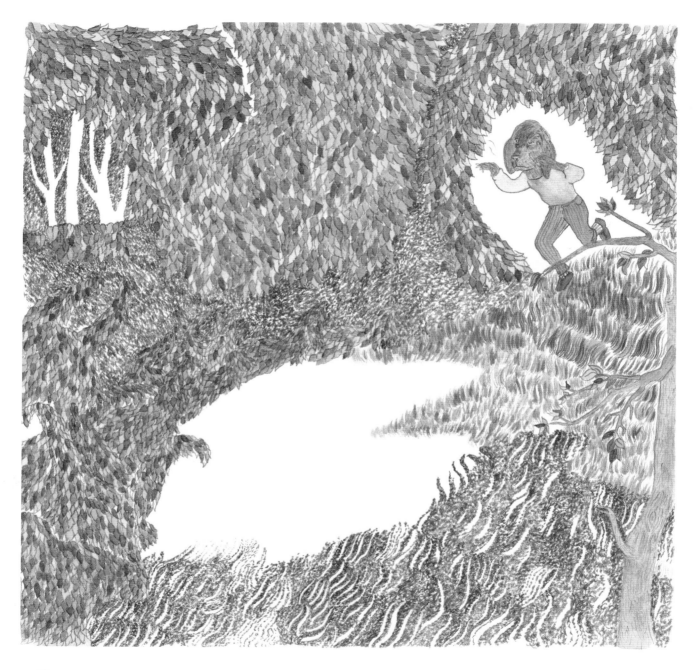

If I could ramble like a hound when he's walkin', walkin' down a
 rabbit trail
If I could ramble like a hound when he's walkin' down a rabbit trail
I'd keep a nose in the wind and believe me people I'd wag my tail

If I had radar hearin' like the bat, like the bat that flies at night
If I had radar hearin' like the bat, like the bat that flies at night
I could hear all the lightnin' bugs turnin' up and turnin' down the
 summer's light

If I only knew what the wise ol' owl knows
If I only knew what that wise ol' owl knows
I'd look all night long, tell the folks about my worldly woes

If I could wallow like the great white whale in the sea
If I could wallow like the great white whale in the sea
I'd rise, I'd sink low, and forever be free

If I could sleep long like the grizzly grizzly bear
If I could sleep long like the grizzly grizzly bear
I'd sleep and I'd dream of your golden hair.

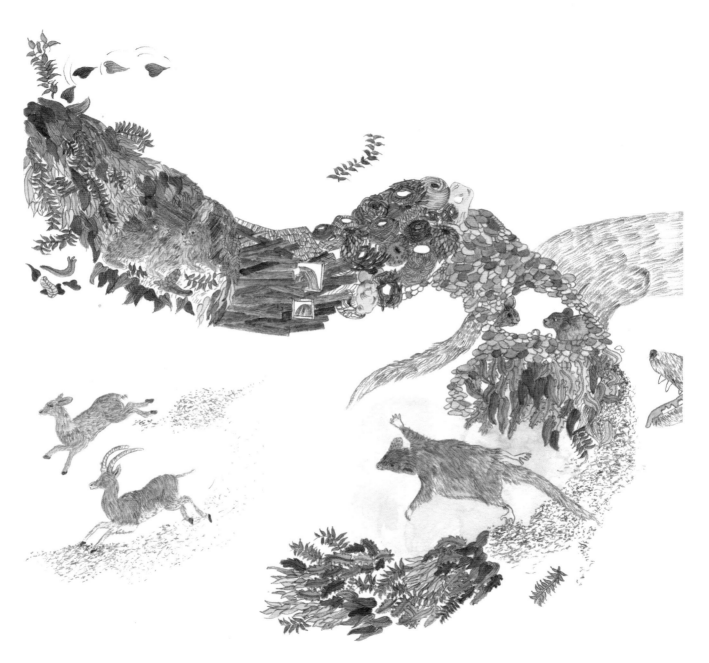

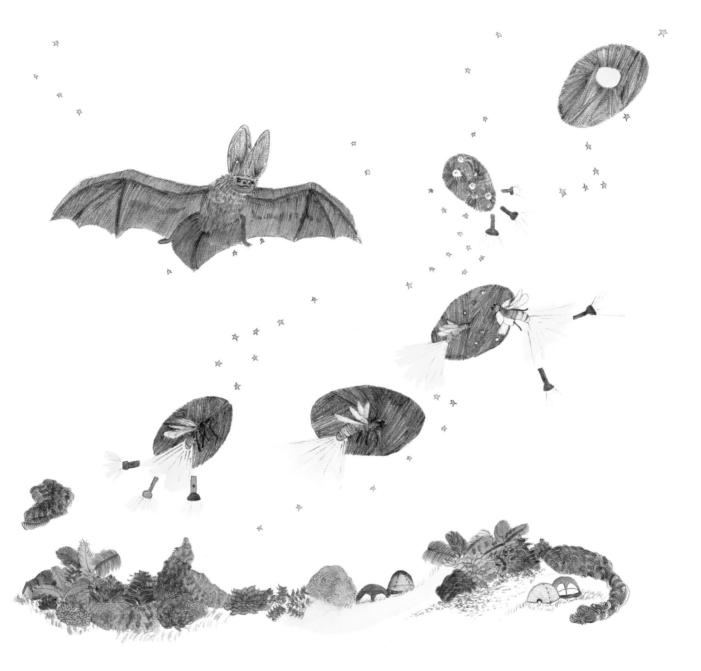

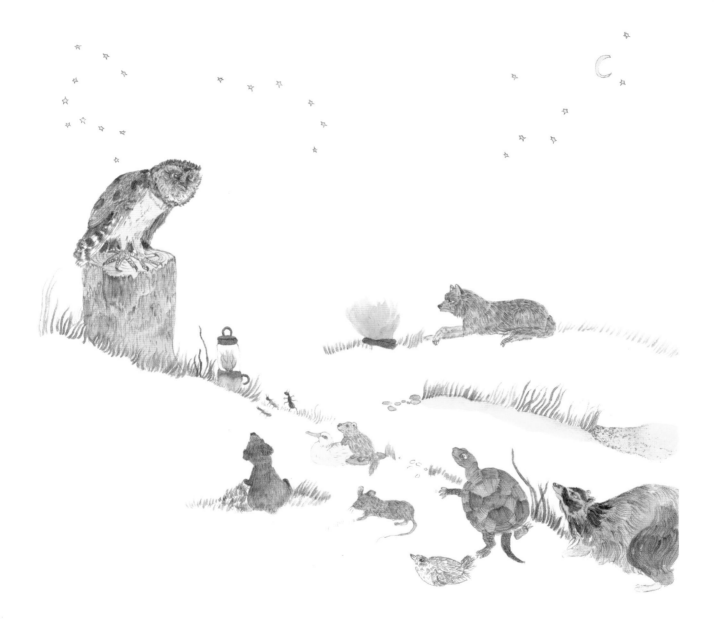

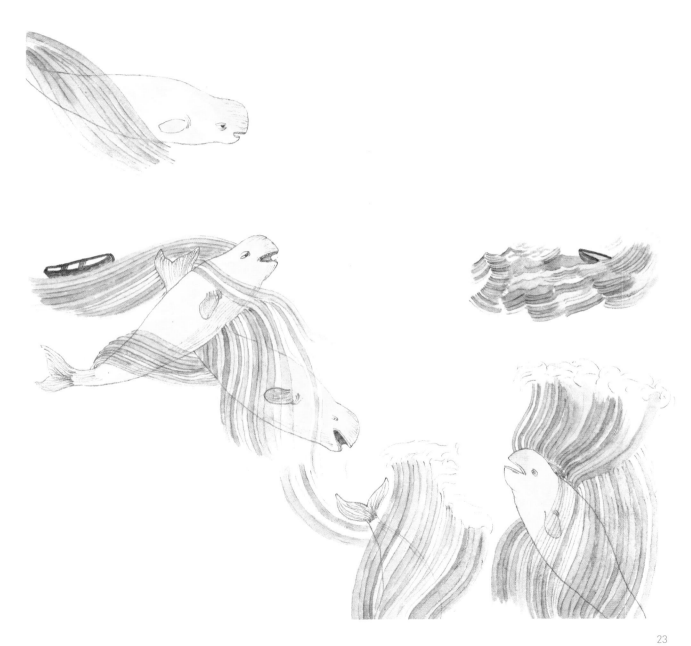

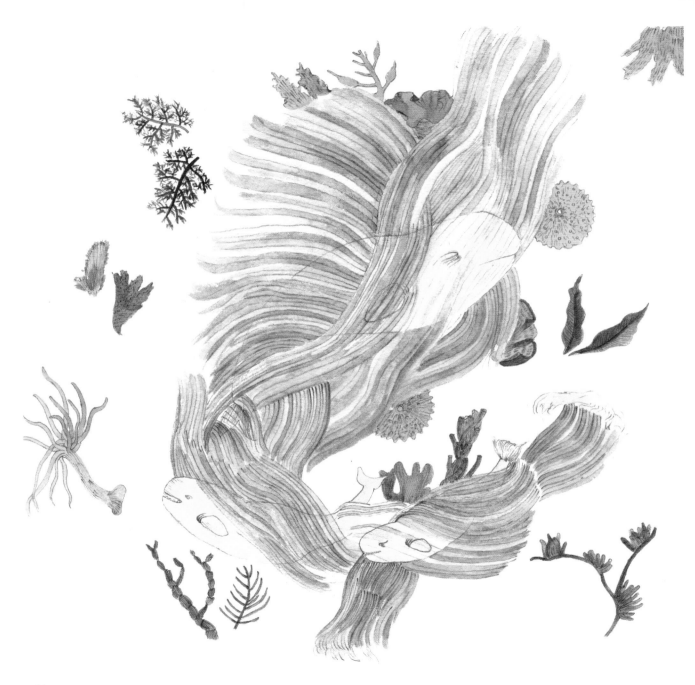

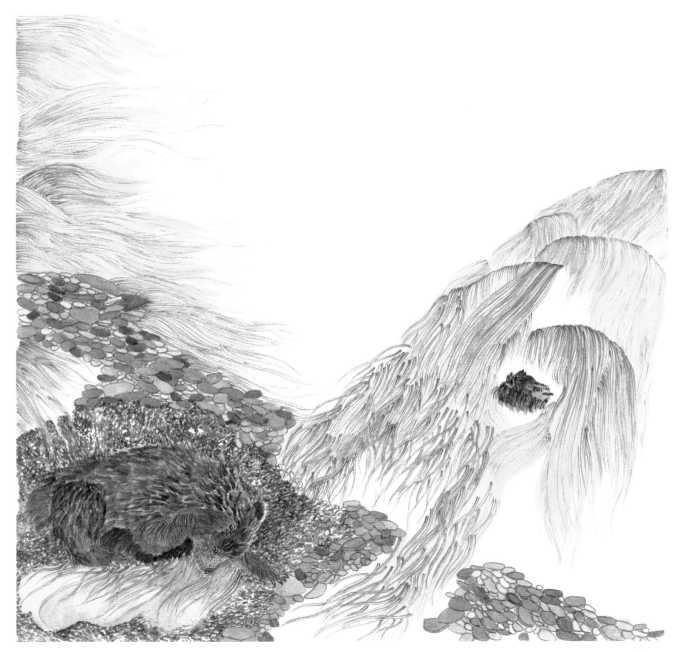

The Animal Song
Michael Hurley

Intro E G A G A Em D G A G

 A D G
If I could ramble like a hound when he's walkin', walkin' down a rabbit trail

 A Em D G Em G
If I could ramble like a hound when he's walkin' down a rabbit trail

 A Em D
I'd keep a nose in the wind and believe me people I'd wag my tail
G A Em D G

 A Em D Em
If I had radar hearin' like the bat, like the bat that flies at night
 G A Em D
If I had radar hearin' like the bat, like the bat that flies at night

 A Em D
I could hear all the lightnin' bugs turnin' up and turnin' down the
 Em G
Summer's light

 A Em D Em
If I only knew what the wise ol' owl knows
G Em D G
If I only knew what that wise ol' owl knows

 A Em D Em G
I'd look all night long, tell the folks about my worldly woes
 A Em D
If I could wallow like the great white whale in the sea
 G A Em D G
If I could wallow like the great white whale in the sea
 A Em D
I'd rise, I'd sink low, and fore- - - - ver be free

 A Em
If I could sleep long like the grizzly grizzly bear
G A D G
 If I could sleep long like the grizzly grizzly bear,
 A Em D G Em G
I'd sleep and I'd dream of your go- - - -lden hair.

"LIGHT GREEN LEAVES"

by Little Wings

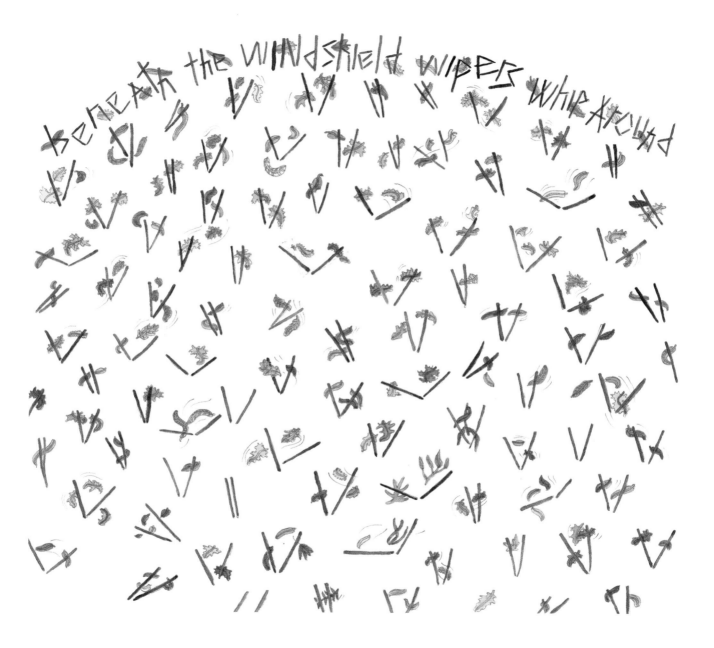

beneath the windshield wipers whiraround

Light green leaves
From the trees
Traffic breathes
And it seems

Light green leaves
From the trees
Never leave
And it seems

Light green leaves
(Beneath your windshield wipers
 whip around)
From the trees
(You comb your hair and walk
 back into town)
Traffic breathes
(The same breath that I breathe
 when I'm around)
And it seems
(We best enjoy them before they
 turn brown)

Light green leaves
(Like feathers on a bird that's
 standing still)
From the trees
(They flock upon the branches
 and they wilt)
Never leave
(As long as they're alive when
 they are found)
And it seems
(They're hanging in the trees but
 soon fall down)

Light green leaves

from the trees

you comb your hair and walk back into town

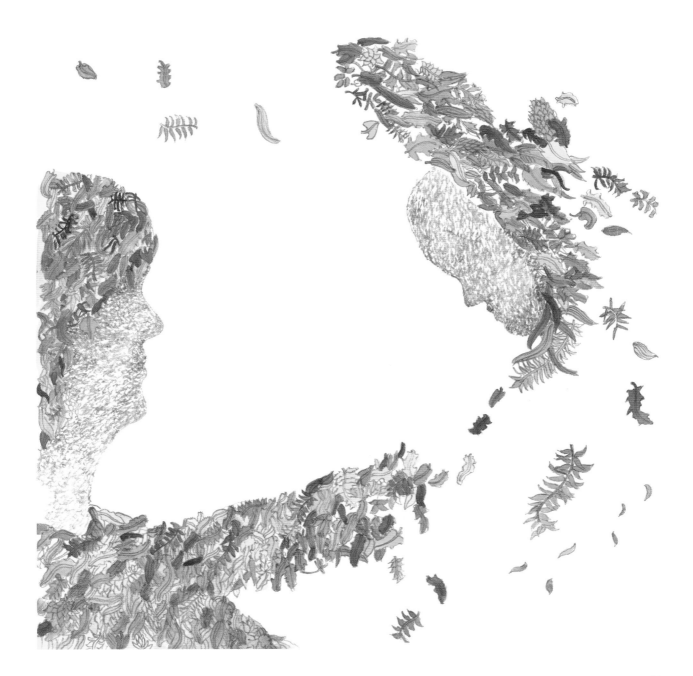

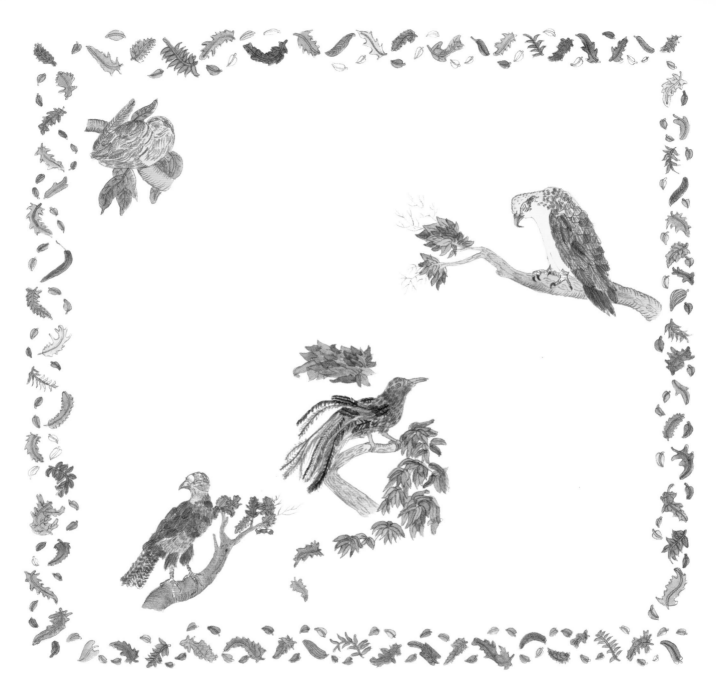

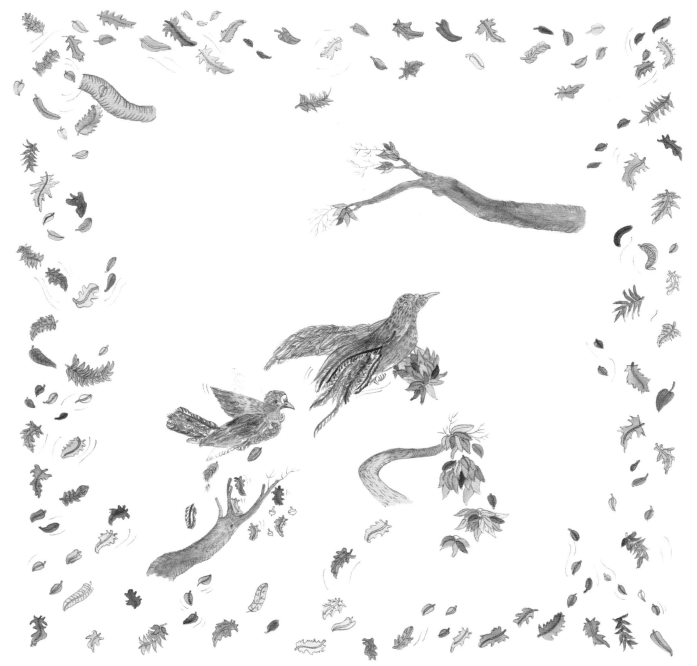

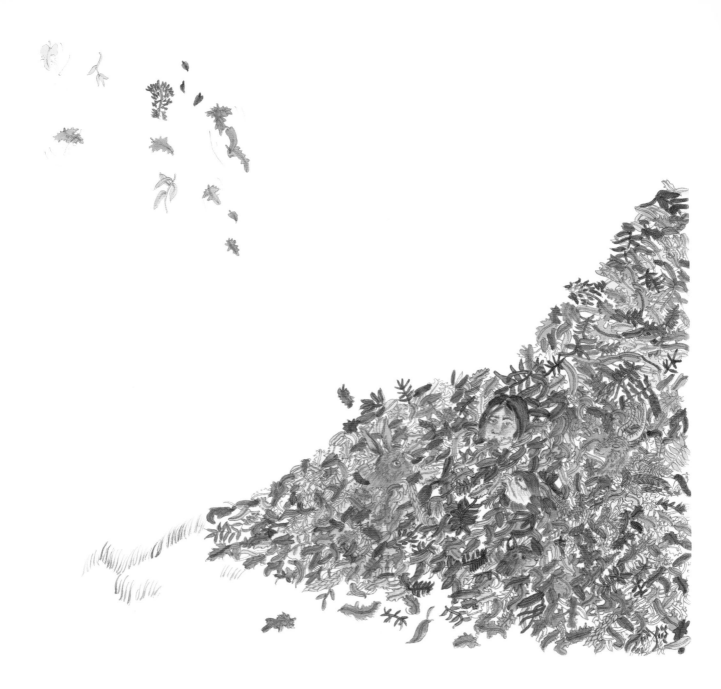

Light Green Leaves

Little Wings

 G
Light green leaves from the trees
G FMaj.7 C G FMaj.7 C
Traffic breathes and it seems
G FMaj.7 C G FMaj.7 C
Light green leaves from the trees
G FMaj.7 C GFMaj.7 C
Never leave and it seems
G FMaj.7 C G FMaj.7
Light green leaves
(Beneath your windshield wipers whip around)
 C GFMaj.7
From the trees
(You comb your hair and walk back into town)
 C G FMaj.7
Traffic breathes
(The same breath that I breathe when I'm around)
 C G FMaj.7
And it seems
(we best enjoy them before they turn brown)

 C G FMaj.7
Light green leaves
(Like feathers on a bird that's standing still)
 C GFMaj.7
From the trees
(They flock upon the branches and they wilt)
 C G FMaj.7
Never leave
(As long as they're alive when they are found)
 C G FMaj.7
And it seems
(They're hanging in the trees but soon fall down)
 C
Light green leaves

"HOME BY THE SEA"

by The Carter Family

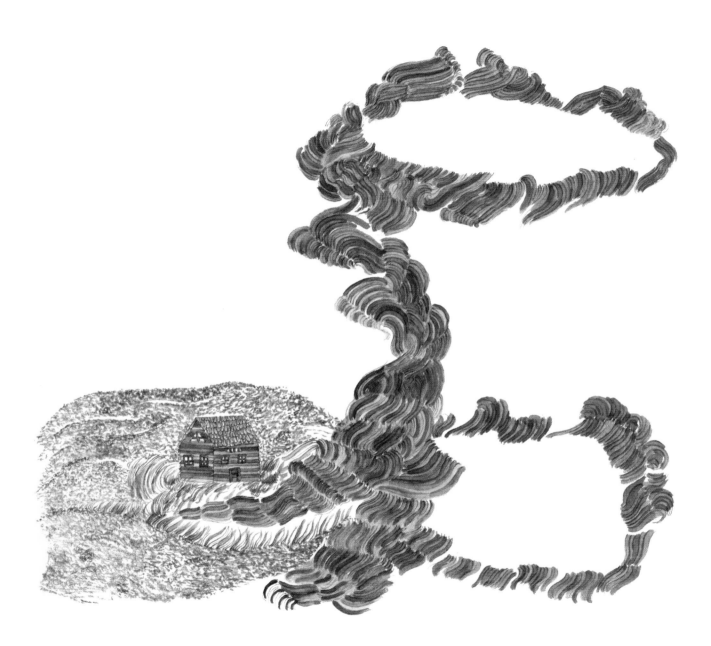

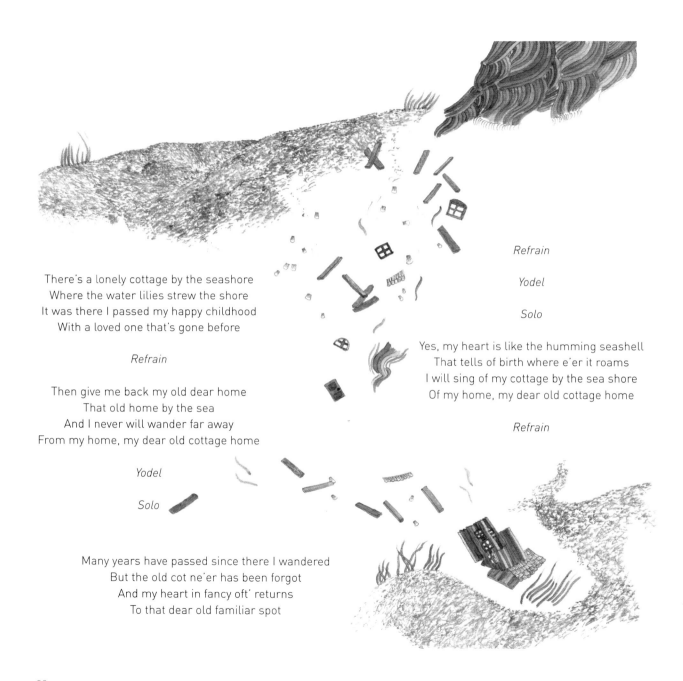

There's a lonely cottage by the seashore
Where the water lilies strew the shore
It was there I passed my happy childhood
With a loved one that's gone before

Refrain

Then give me back my old dear home
That old home by the sea
And I never will wander far away
From my home, my dear old cottage home

Yodel

Solo

Many years have passed since there I wandered
But the old cot ne'er has been forgot
And my heart in fancy oft' returns
To that dear old familiar spot

Refrain

Yodel

Solo

Yes, my heart is like the humming seashell
That tells of birth where e'er it roams
I will sing of my cottage by the sea shore
Of my home, my dear old cottage home

Refrain

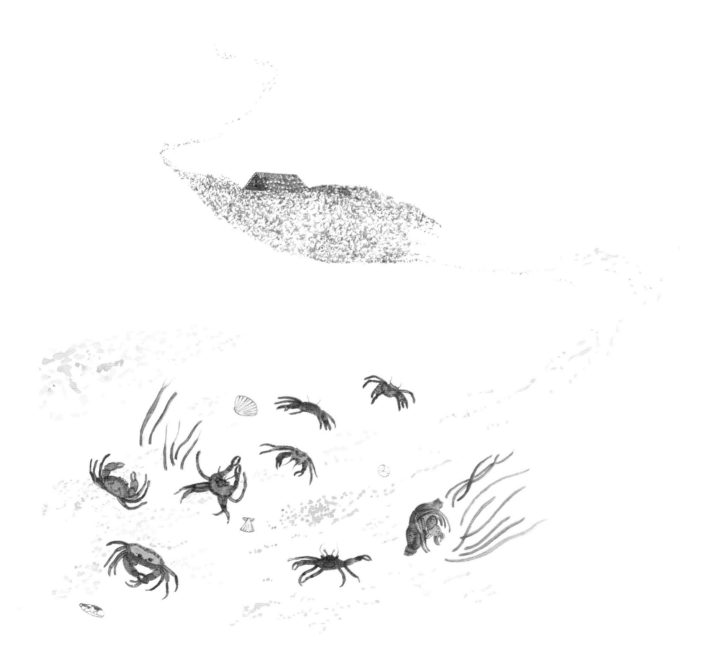

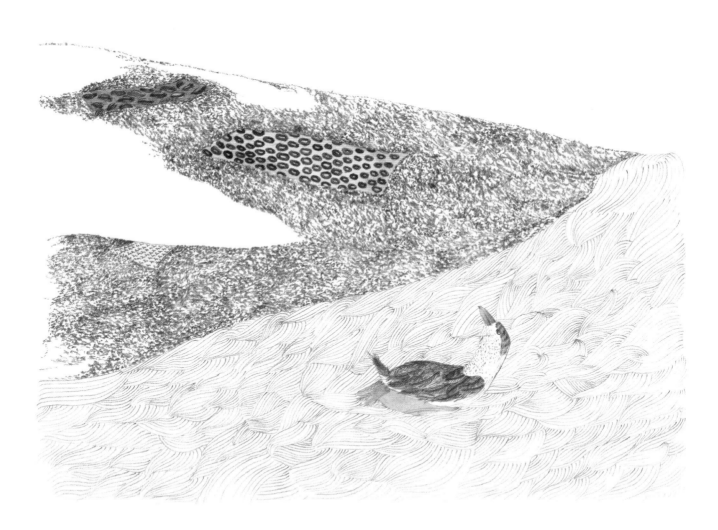

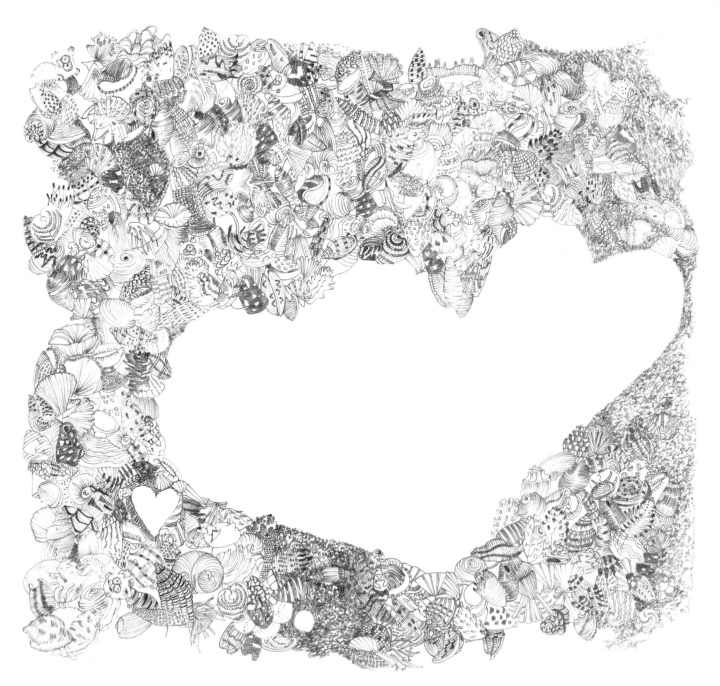

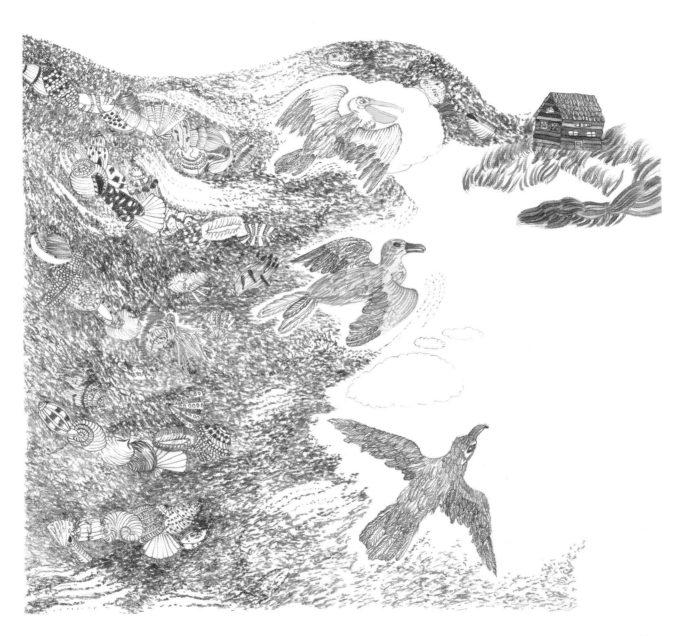

Home By The Sea
The Carter Family

D G D G D A7 D (chorus)

D
There's a lonely cottage by the seashore
 G D
Where the water lilies strew the shore
 D
It was there I passed my happy childhood
 A7
 With a loved one that's gone before
 D
Then give me back my old dear home
 G D
 That old home by the sea
 D G D
 And I will never wander far away
 A7 D
From my home, my dear old cottage home

Many years have passed since there I wandered
 G D
 But the old cot ne'er has been forgot
 D
 And my heart in fancy oft' returns
 A7
 To that dear old familiar spot
 D
Yes, my heart is like the humming seashell
 G D
 That tells of birth where e'er it roams
 D
 I will sing of my cottage by the seashore
 A7
 Of my home, my dear old cottage home

"WINTER'S COME AND GONE"

by Gillian Welch and David Rawlings

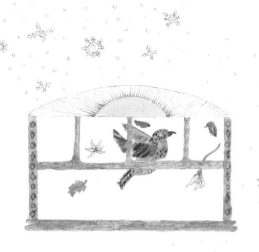

Oh little red bird
Come to my window
sill

Been so lonesome
Shaking that
morning chill

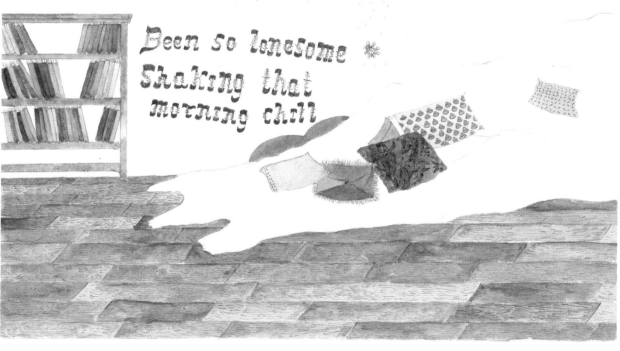

46

Oh little red bird
Come to my window sill
Been so lonesome
Shaking that morning chill
Oh little red bird
Open your mouth and say
Been so lonesome
Just about flown away

So long now I've been out
In the rain and snow
But winter's come and gone
A little bird told me so

Oh little blue bird
Pearly feather breast
Five cold nickels all I got left
Oh little blue bird
What am I gonna do
Five cold nickels
Ain't gonna see me through

So long now I've been out
In the rain and snow
But winter's come and gone
A little bird told me so

Oh little black bird
On my wire line
Dark as trouble
In this heart of mine
Poor little black bird
Sings a worried song
Dark as trouble
'Til winter's come and gone

So long now I've been out
In the rain and snow
But winter's come and gone
A little bird told me so

So long now I've been out
In the rain and snow
But winter's come and gone
A little bird told me so

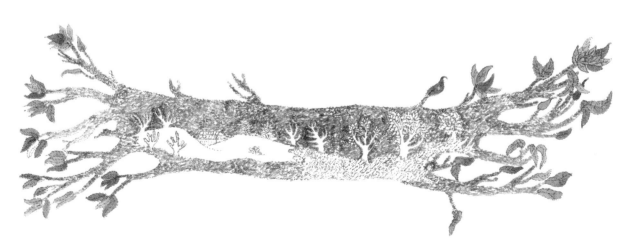

Oh little red bird
Open your mouth and say

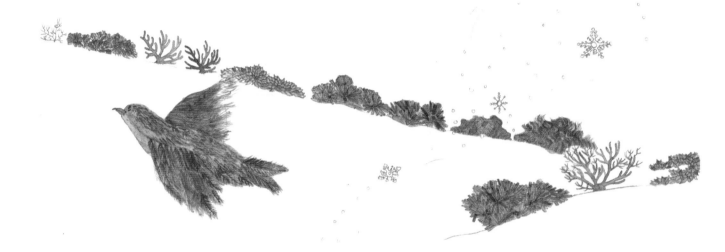

Been so lonesome
Just about flown away

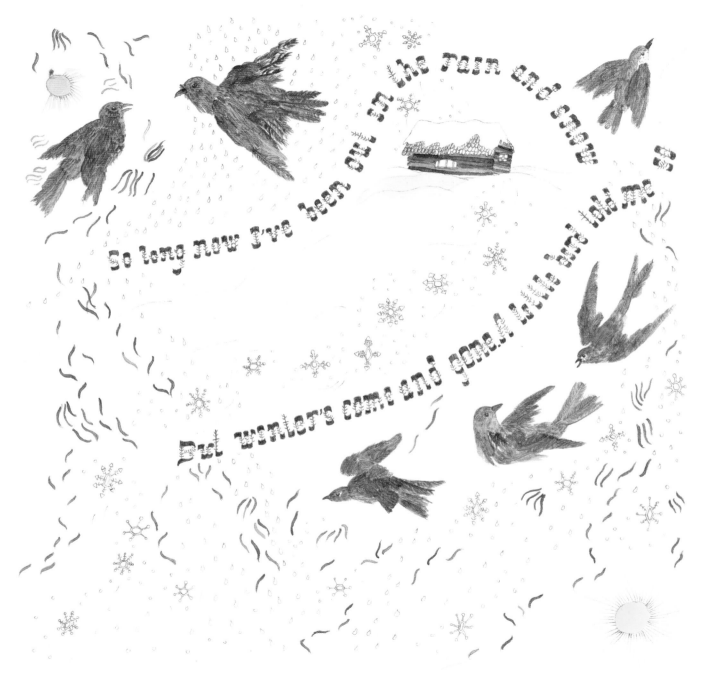

So long now I've been out in the rain and snow. But winter's come and gone, a little bird told me so

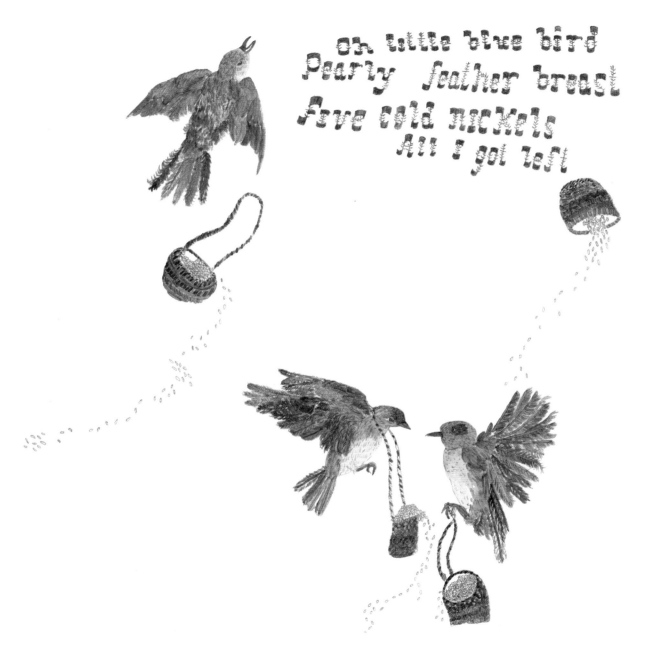

Oh little blue bird
Pearly feather breast
Five cold nickels
All I got left

Oh little blue bird
What am I gonna do
Five cold nickels
Asn't gonna see me through

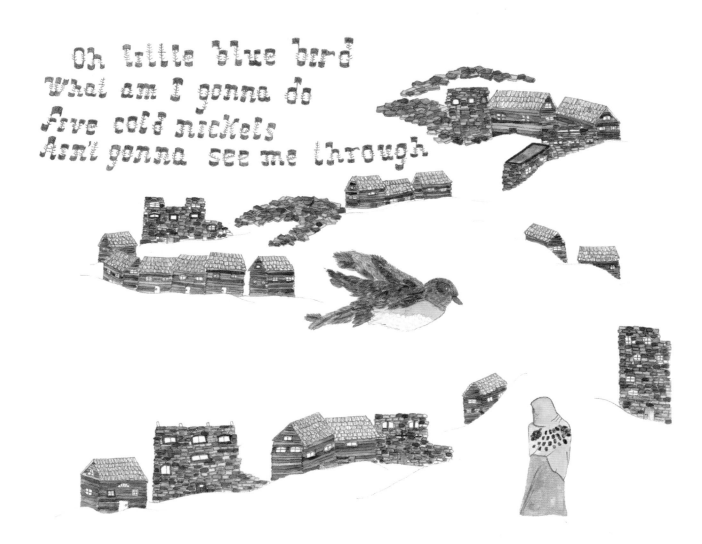

So long now

I've been out in the rain and snow

But winter's come and gone

A little bird told me so

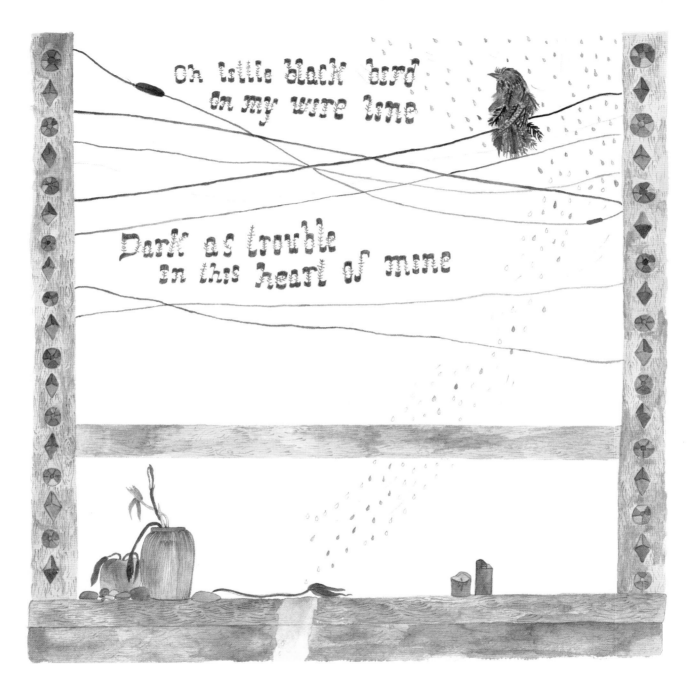

Oh little black bird
on my wire line

Dark as trouble
in this heart of mine

Poor little black bird
Sings a worried song
Dark as trouble
'till winter's come and gone

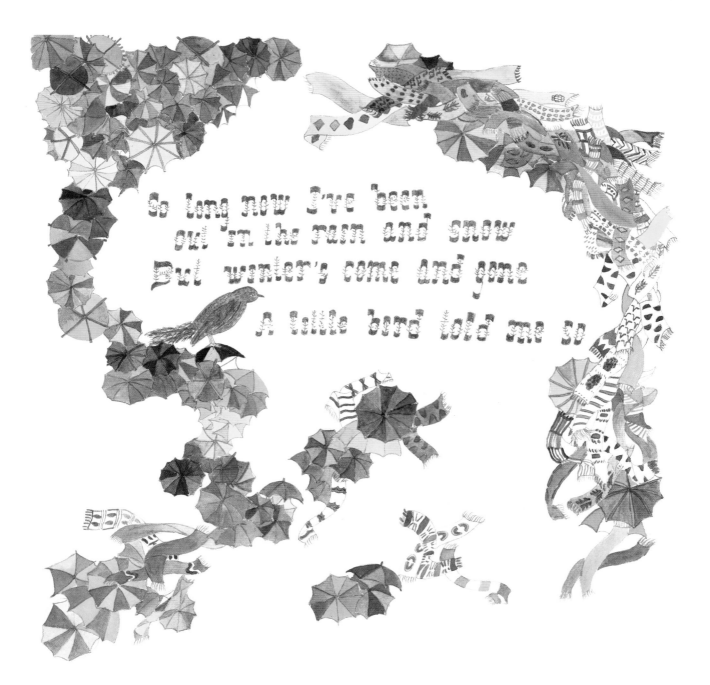

So long now I've been
out 'n the rain and snow
But winter's come and gone
A little bird told me so

Winter's Come and Gone
Gillian Welch & David Rawlings

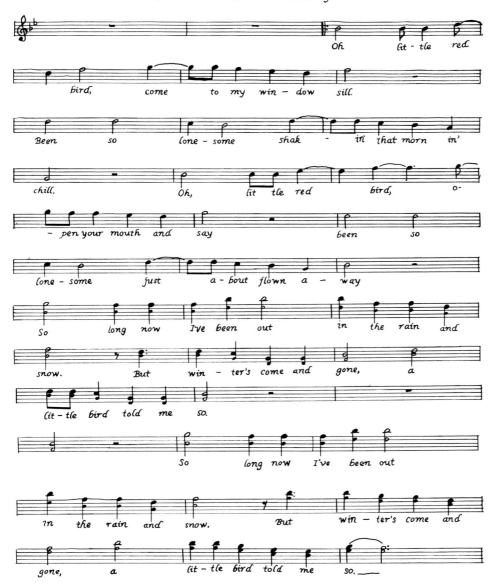

Oh, lit - tle red bird, come to my win — dow sill. Been so lone - some shak - in' that morn in' chill. Oh, lit tle red bird, o- pen your mouth and say been so lone - some just a - bout flown a — way So long now I've been out in the rain and snow. But win — ter's come and gone, a lit - tle bird told me so. So long now I've been out in the rain and snow. But win — ter's come and gone, a lit - tle bird told me so.

"THE WATER IS WIDE"

Traditional Scottish ballad
sung since the 1600s

The water is wide, I cannot get o'er.
And neither have I wings to fly.
Oh go and get me some little boat
To carry o'er my true love and I.
A ship there is and she sails the seas.
She's laden deep, as deep can be;
But not so deep as the love I'm in
And I know not if I sink or swim.
I leaned my back up against a young oak
Thinking he were a trusty tree
but first he bended and then he broke
Thus did my love prove false to me.
O love is handsome and love is fine
and love is charming when it is true
As it grows older it groweth colder
And fades away like the morning dew.

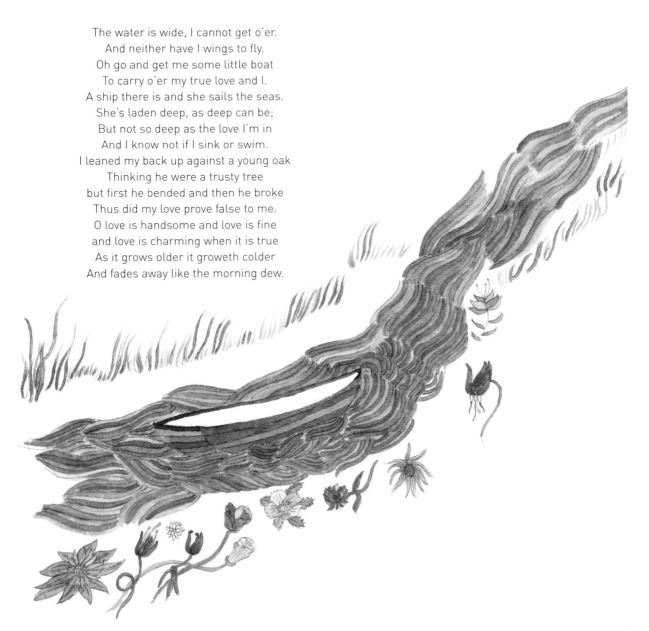

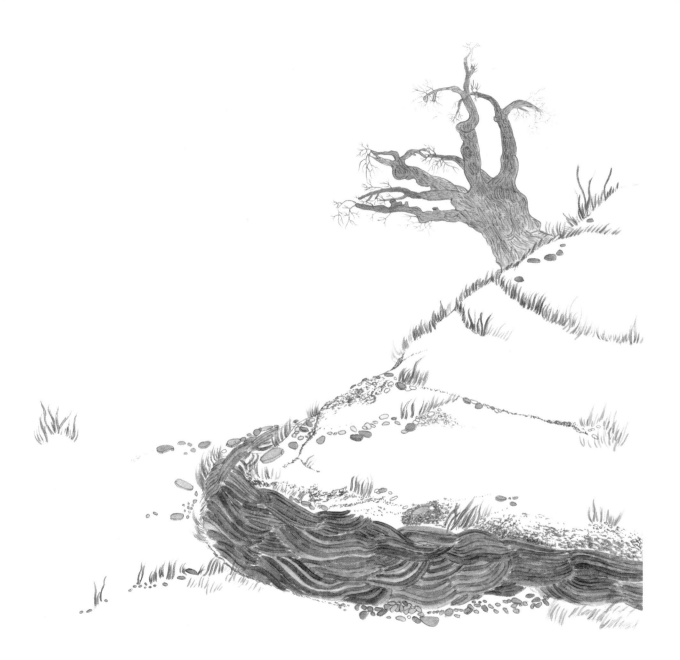

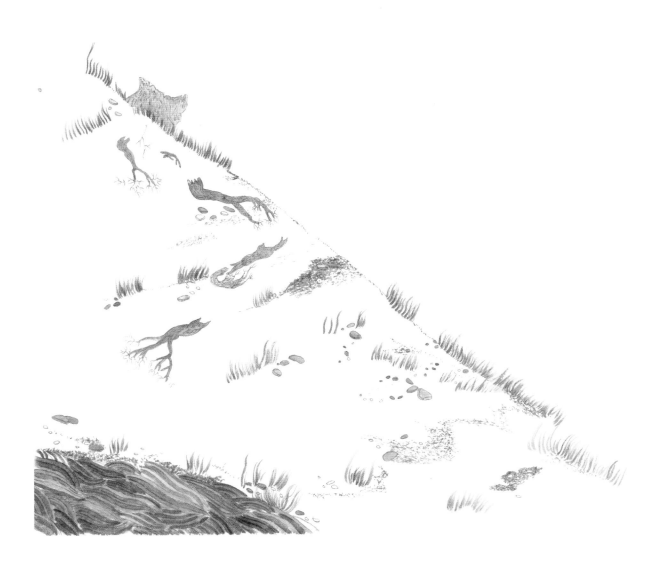

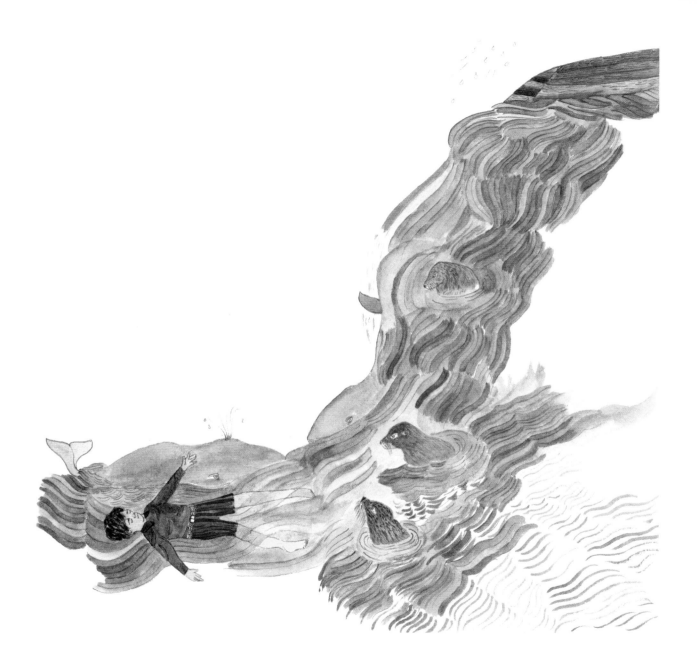

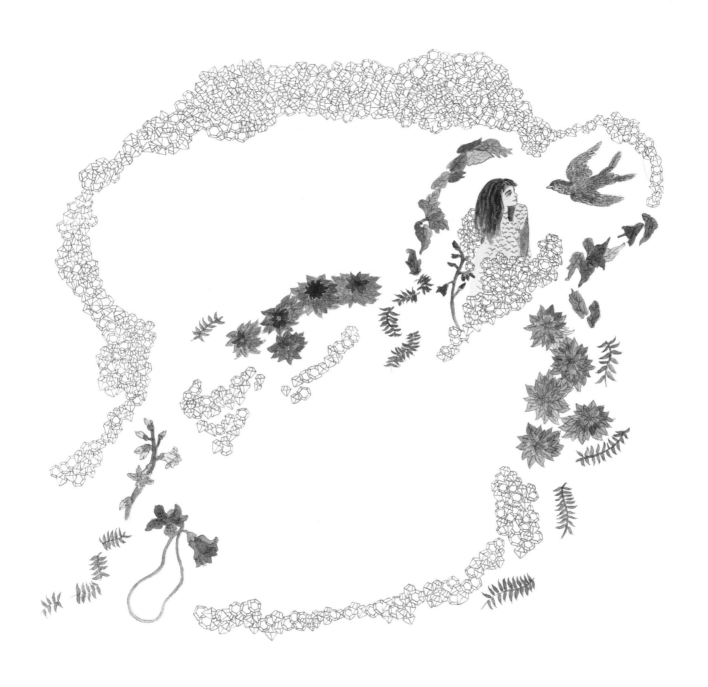

The Water is Wide
O Waly, Waly
One variation of this Traditional Scottish ballad

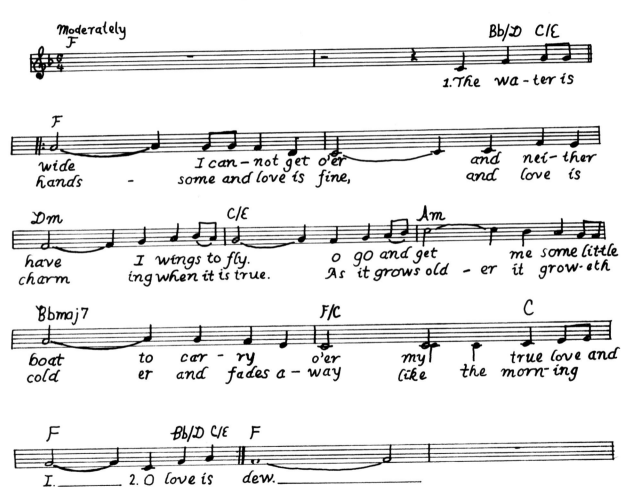

"THE BLACKBIRD AND THE CROW"

Traditional ballad collected by Marshall Bartholomew on
Smithsonian Folkways' *All Day Singin': Louisiana and Smoky Mountain Ballads*

Said the blackbird to the crow,
"What makes these folks hate us so?"
Ever since old Adam's been born,
It's been our habit to pull corn.

Hi! says the blackbird, sitting on a chair,
Once I courted a lady fair;
She proved fickle and turned her back,
And ever since then I've dressed in black.

Hi! says the woodpecker sitting on a fence,
Once I courted a handsome wench;
She proved fickle and from me fled,
And ever since then my head's been red.

Hi! says the robin, as away he flew,
When I was a young one I chose two;
If one didn't have me, the other one would,
Now, don't you think that notion's good?

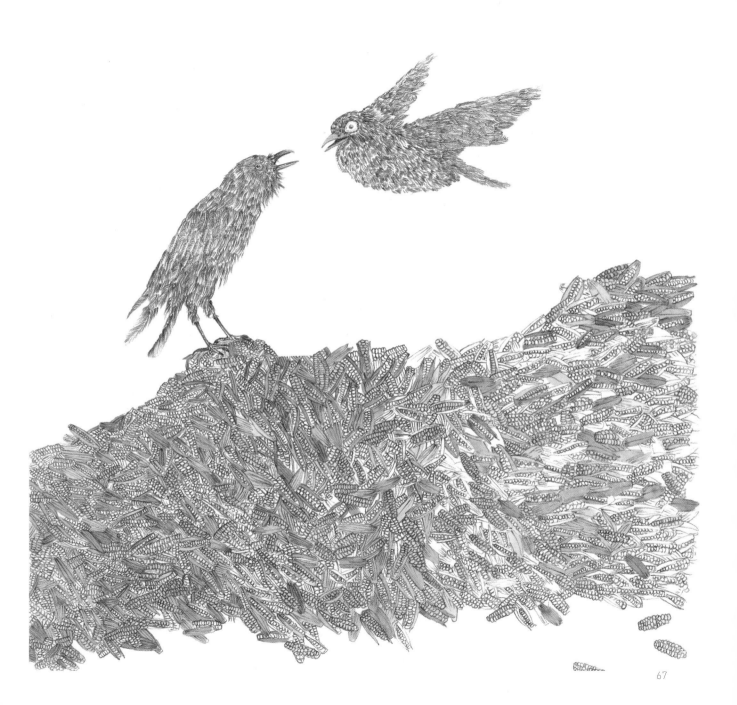

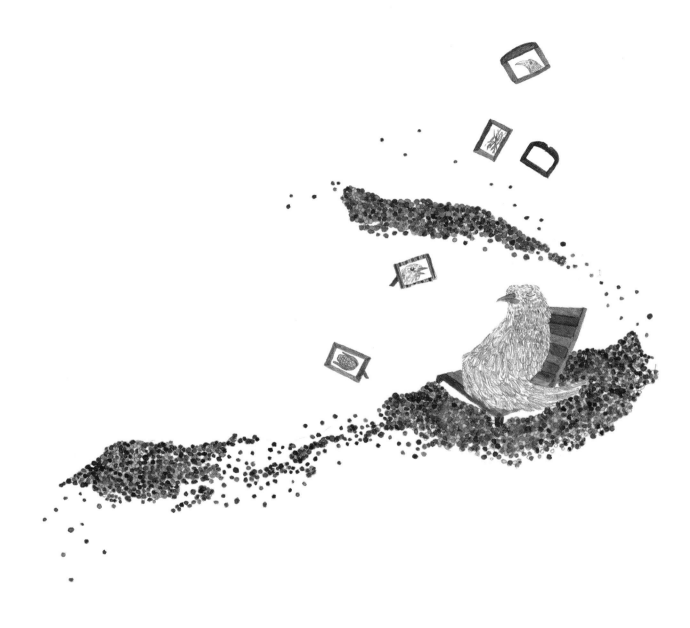

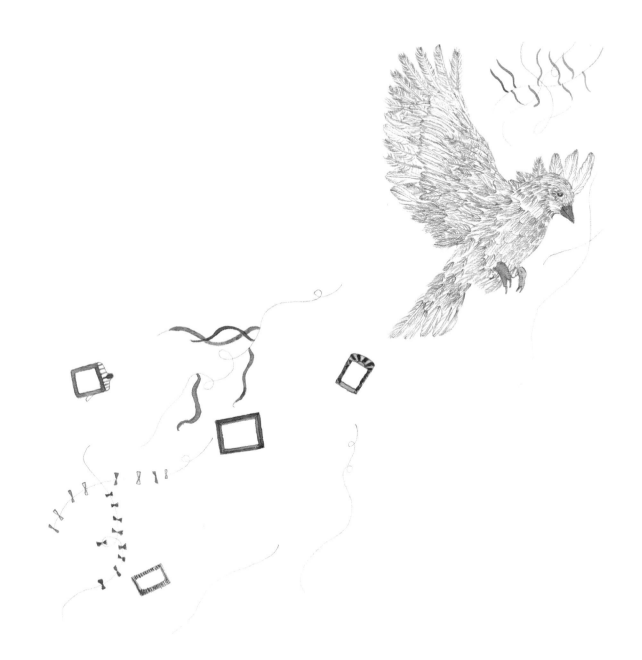

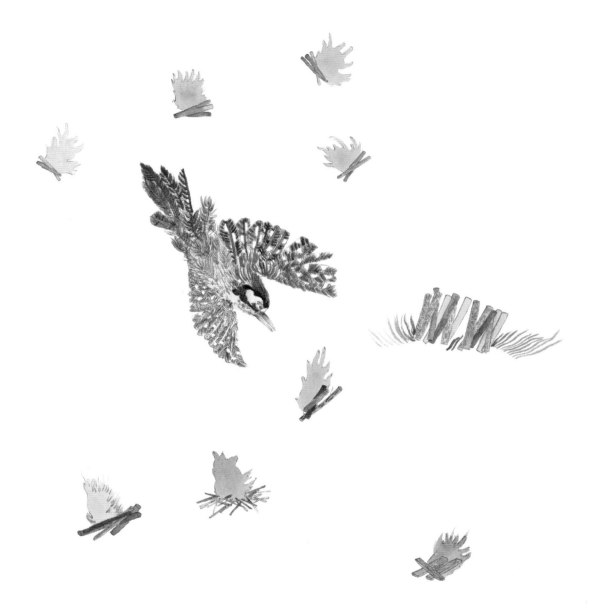

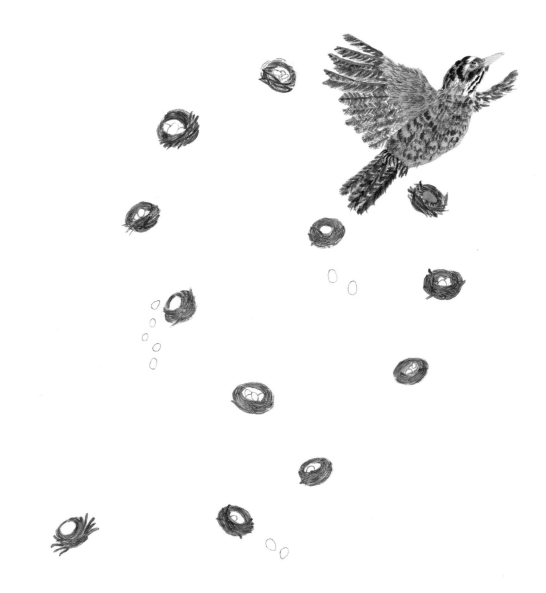

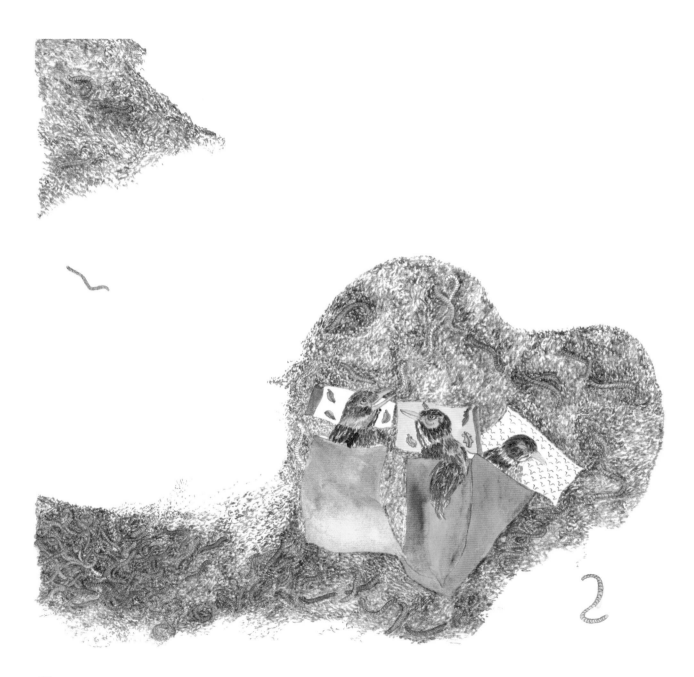

The Blackbird and the Crow
Traditional ballad

Said the blackbird to the crow, "What makes these folks hate us so?"

Ev- er since old Adam's been born, it's been our habit to pull corn. (repeat)

Hi! says the blackbird, sitting on a chair,
once I courted a lady fair;
She proved fickle and turned her back,
And ever since then I've dressed in black.

Hi! says the woodpecker sitting on a fence,
Once I courted a handsome wench;
She proved fickle and from me fled,
And ever since then my head's been red.

Hi! says the robin, as away he flew,
When I was a young one I chose two;
If one didn't have me, the other one would,
Now, don't you think that notion's good?

"I WISH I WAS A MOLE IN THE GROUND"

Traditional American folk song most famously
recorded and archived in the Library of Congress
by Bascom Lamar Lunsford in 1924

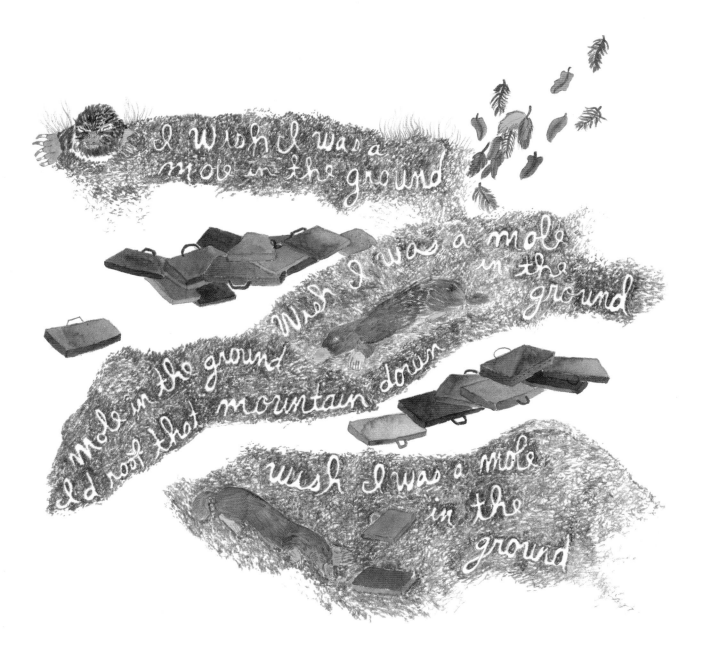

I Wish I was a mole in the ground

Wish I was a mole in the ground

Mole in the ground

Wish I was a mole in the ground

I'd root that mountain down

Wish I was a mole in the ground

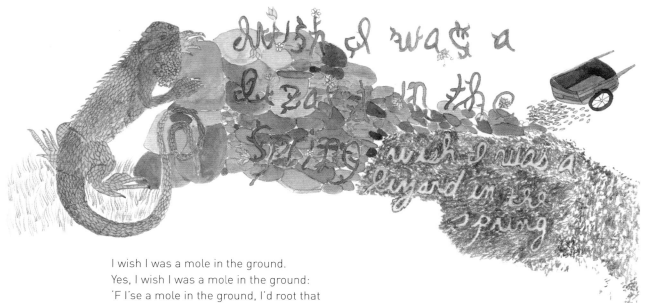

I wish I was a mole in the ground.
Yes, I wish I was a mole in the ground:
'F I'se a mole in the ground, I'd root that
　　mountain down,
And I wish I was a mole in the ground.

Oh, Kimpy wants a nine-dollar shawl.
Yes, Kimpy wants a nine-dollar shawl;
When I come o'er the hill with a forty-
　　dollar bill,
'Tis "Baby, where you been so long?"

I been in the pen so long.
Yes, I been in the pen so long;
I been in the pen with the rough and
　　rowdy men.
'Tis "Baby, where you been so long?"

Don't marry a railroad man.
Don't marry a railroad man;
A railroad man is gonna kill you if he can,
And drink up your blood like wine.

I wish I was a lizard in the spring.
Yes, I wish I was a lizard in the spring;
'F I'se a lizard in the spring, I'd hear my
　　darlin' sing,
An' I wish l was a lizard in the spring.

Come, Kimpy, let your hair roll down.
Kimpy let your hair roll down;
Let your hair roll down and your bangs
　　curl around,
Oh, Kimpy, let your hair roll down.

I wish I was a mole in the ground.
Yes, I wish I was a mole in the ground:
'F I'se a mole in the ground, I'd root that
　　mountain down,
An' I wish I was a mole in the ground.

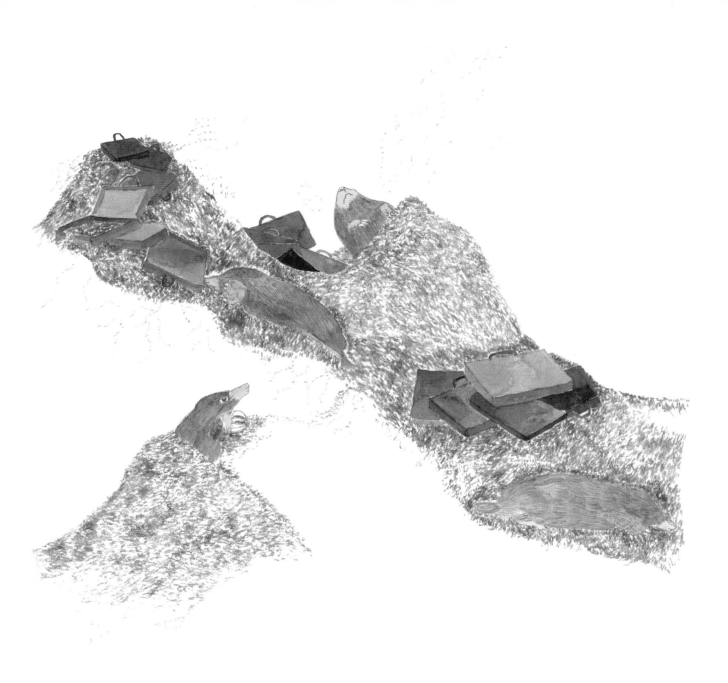

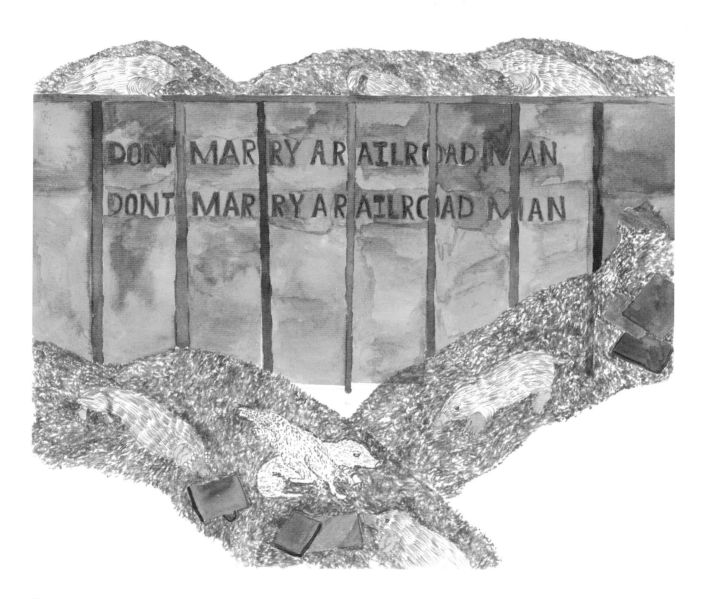

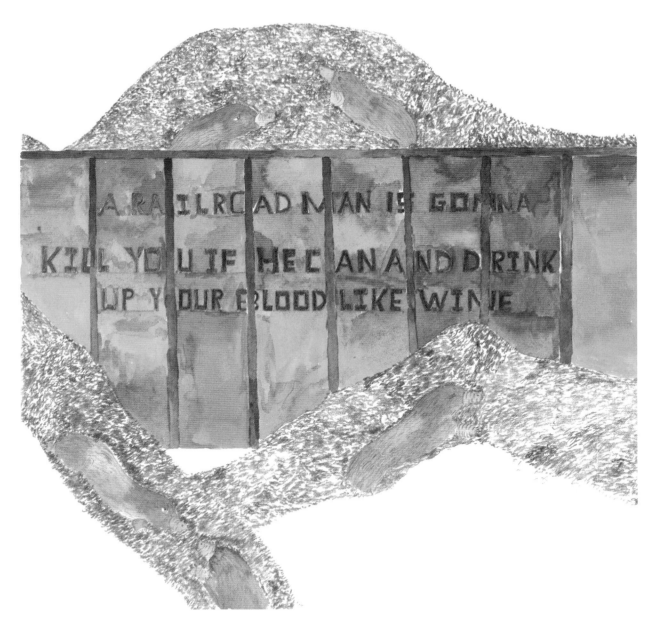

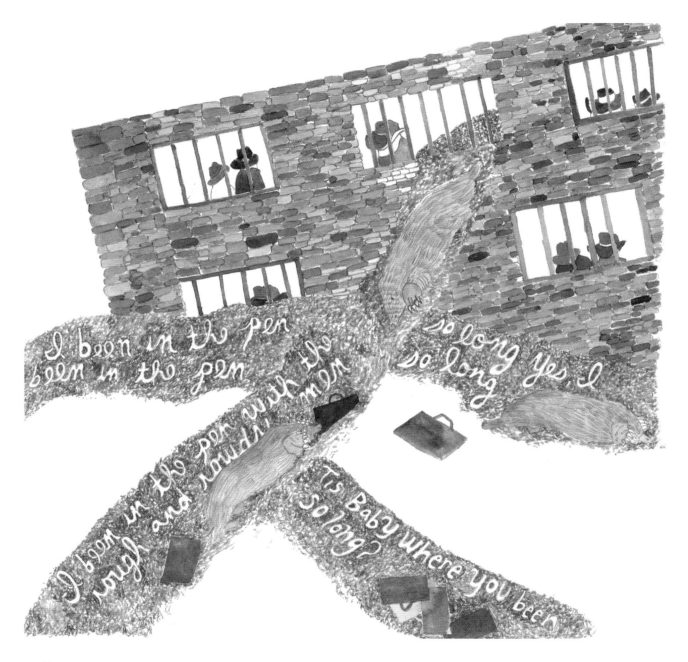

I Wish I Was a Mole in the Ground
Traditional American folk song

Oh, Kimpy wants a nine-dollar shawl.
Yes, Kimpy wants a nine-dollar shawl;
When I come o'er the hill with a forty-dollar bill,
'Tis "Baby, where you been so long?"

I been in the pen so long.
Yes, I been in the pen so long;
I been in the pen with the rough and rowdy men.
'Tis "Baby, where you been so long?"

Don't marry a railroad man.
Don't marry a railroad man;
A railroad man is gonna kill you if he can,
And drink up your blood like wine.

I wish I was a lizard in the spring.
Yes, I wish I was a lizard in the spring;
'F I'se a lizard in the spring, I'd hear my darlin' sing,
An' I wish I was a lizard in the spring.

Come, Kimpy, let your hair roll down.
Kimpy let your hair roll down;
Let your hair roll down and your bangs curl around,
Oh, Kimpy, let your hair roll down.

Chorus
I wish I was a mole in the ground
Yes, I wish I was a mole in the ground
'F I'se a mole in the ground, I'd root that mountain down,
And I wish I was a mole in the ground

"AND THE GREEN GRASS GROWS ALL AROUND"

By William Jerome and Harry Von Tilzer

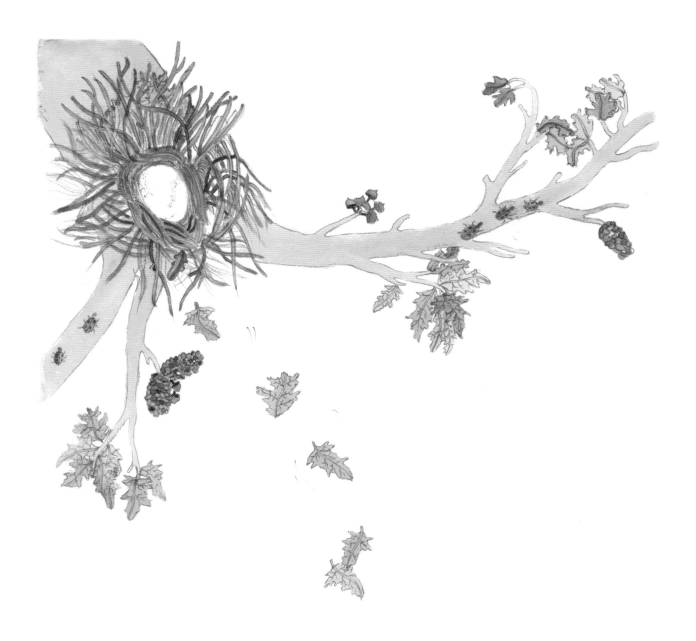

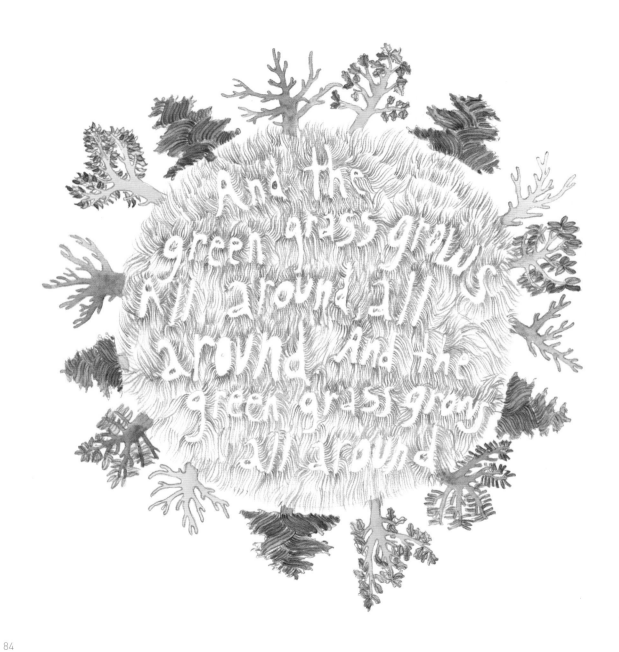

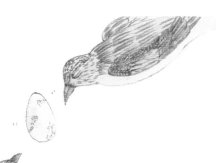

There was a tree
All in the wood
The prettiest tree
That you ever did see

Now the tree in a hole
And the hole in the ground
And the green grass grows all
 around, all around
The green grass grows all around

And on that tree
There was a limb
The prettiest limb
That you ever did see

Now the limb on the tree,
And the tree in a hole,
And the hole in the ground
And the green grass grows all
 around, all around
And the green grass grows
 all around.

And on that limb
There was a branch
The prettiest branch
That you ever did see

Now the branch on the limb,
And the limb on the tree,

And the tree in a hole,
And the hole in the ground
And the green grass grows all
 around, all around
And the green grass grows
 all around.

And on that branch
There was a nest
The prettiest nest
That you ever did see

Now the nest on the branch,
And the branch on the limb,
And the limb on the tree,
And the tree in a hole,
And the hole in the ground
And the green grass grows all
 around, all around
And the green grass grows
 all around.

And in that nest
There was an egg
The prettiest egg
That you ever did see

Now the egg in the nest,
And the nest on the branch,
And the branch on the limb,
And the limb on the tree,
And the tree in a hole,
And the hole in the ground
And the green grass grows all
 around, all around
And the green grass grows
 all around.

And in that egg
There was a bird
The prettiest bird
That you ever did see

Now the bird in the egg,
And the egg in the nest,
And the nest on the branch,
And the branch on the limb,
And the limb on the tree,
And the tree in a hole,
And the hole in the ground
And the green grass grows all
 around, all around
And the green grass grows
 all around.

And on that bird
There was a wing
The prettiest wing
That you ever did see

Now the wing on the bird,
And the bird in the egg,
And the egg in the nest,
And the nest on the branch,
And the branch on the limb,
And the limb on the tree,
And the tree in a hole,
And the hole in the ground
And the green grass grows all
 around, all around
And the green grass grows
 all around.

And on that wing
There was a feather
The prettiest feather
That you ever did see

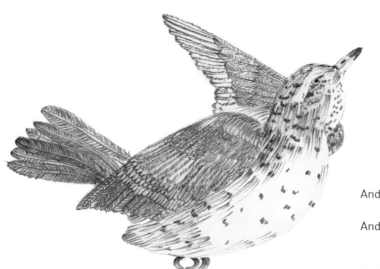

And the green grass grows all
 around, all around
And the green grass grows
 all around.

And on that feather
There was a bug
The prettiest bug
That you ever did see

Now the bug on the feather,
And the feather on the wing,
And the wing on the bird,
And the bird in the egg,
And the egg in the nest,
And the nest on the branch,
And the branch on the limb,
And the limb on the tree,
And the tree in a hole,
And the hole in the ground

And the green grass grows all
 around, all around
And the green grass grows
 all around.

And on that bug
There was a germ
The prettiest germ
That you ever did see

And the germ on the bug,
And the bug on the feather,
And the feather on the wing,
And the wing on the bird,
And the bird in the egg,
And the egg in the nest,
And the nest on the branch,
And the branch on the limb,
And the limb on the tree,
And the tree in a hole,
And the hole in the ground
And the green grass grows all
 around, all around
Now the green grass grows
 all around.

Yes, the green grass grows all
 around, all around
The green grass grows all around!

Now the feather on the wing,
And the wing on the bird,
And the bird in the egg,
And the egg in the nest,
And the nest on the branch,
And the branch on the limb,
And the limb on the tree,
And the tree in a hole,
And the hole in the ground

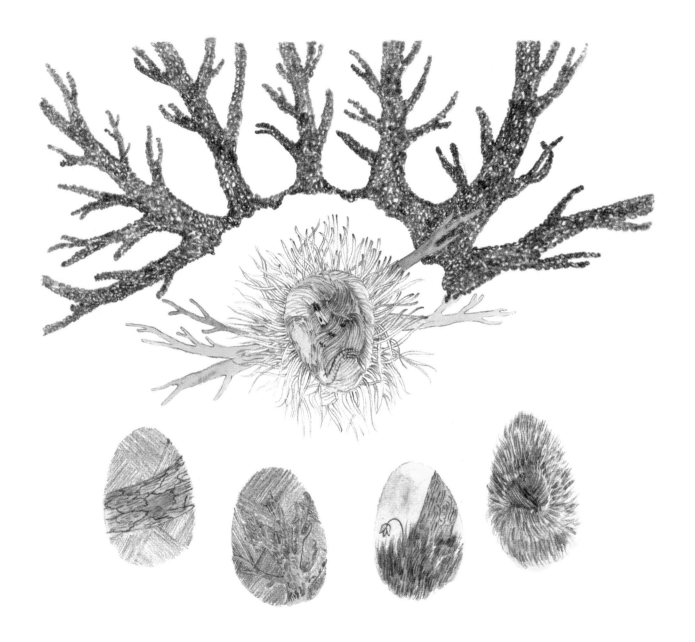

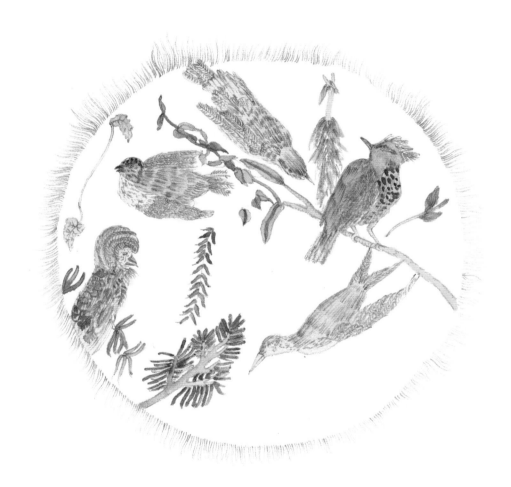

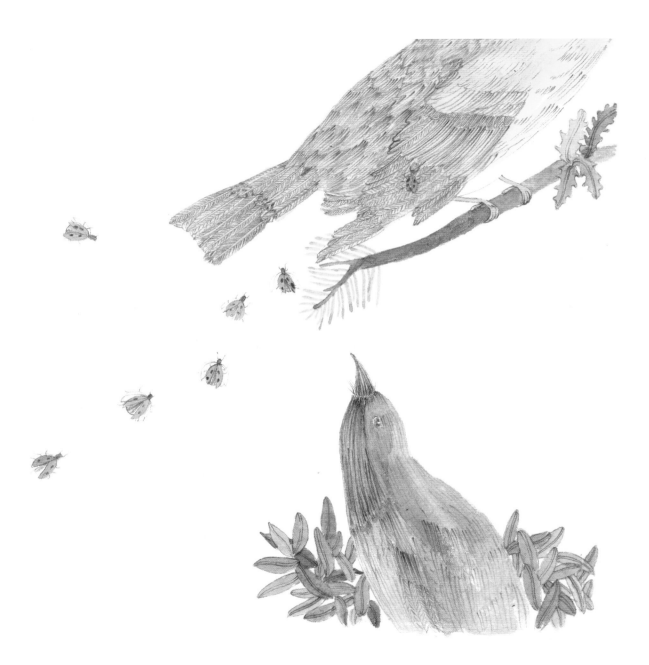

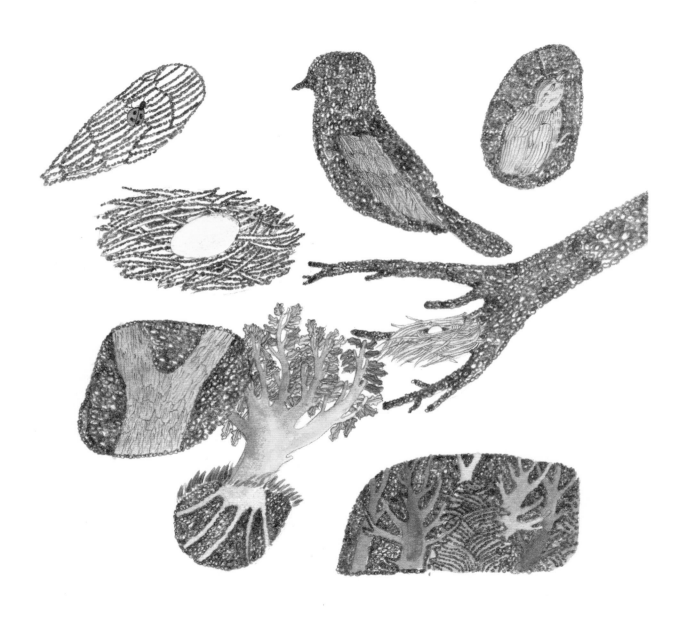

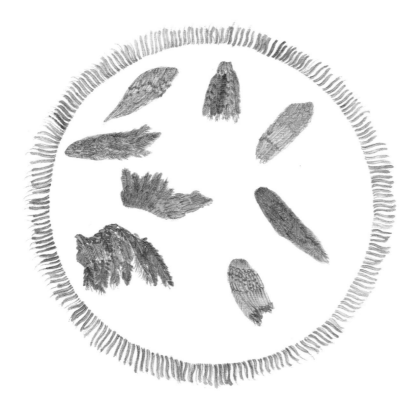

And The Green Grass Grows All Around
By William Jerome and Harry Von Tilzer

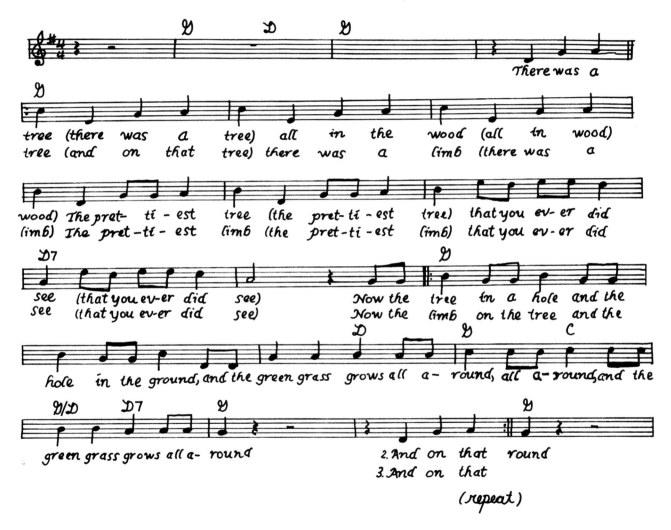

"HOME ON THE RANGE"

by Dr. Brewster M. Higley

Oh, give me a home where the buffalo roam,
Where deer and the antelope play.
Where seldom is heard a discouraging word,
And the sky is not cloudy all day.

Chorus

A home! A home! On the range,
Where deer and the antelope play,
Where seldom is heard a discouraging word,
And the sky is not cloudy all day.

Often at night, when the heavens' bright,
With the light of the twinkling stars,
Have I stood here amazed, and asked as I gazed,
If their glory exceeds that of ours.

Chorus

Oh! Give me a land where the bright diamond sand
Throws its light from the glittering streams,
Where glideth along the graceful white swan,
Like the maid in her heavenly dreams.

Chorus

Oh! Give me a gale of the Solomon vale,
Where the life streams with buoyancy flow;
On the banks of the beaver, where seldom if ever,
Any poisonous herbage doth grow.

Chorus

Oh, I love the wild flowers in this bright land of ours,
I love the wild curlew's shrill scream;
The bluffs and white rocks, and antelope flocks
That graze on the mountains so green.

Chorus

Where the air is so pure and the breezes so fine,
The zephyrs so balmy and light,
That I would not exchange my home on the range
Forever in azures so bright.

Chorus

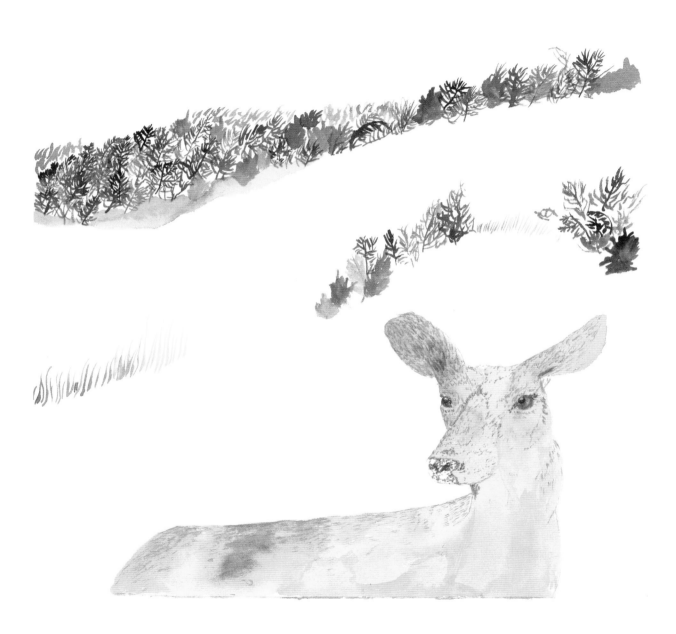

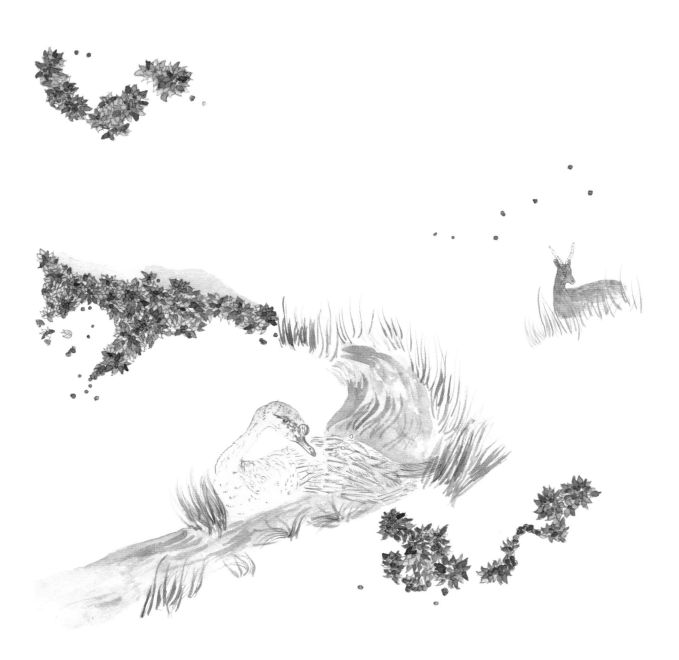

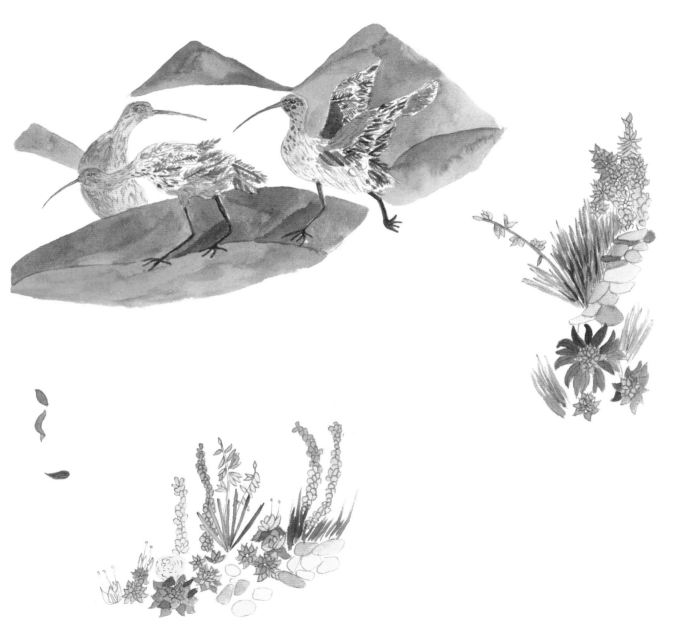

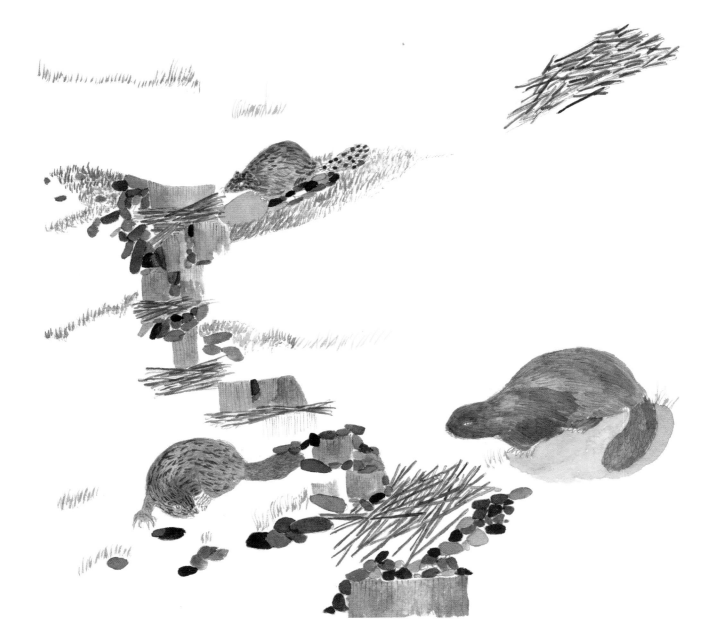

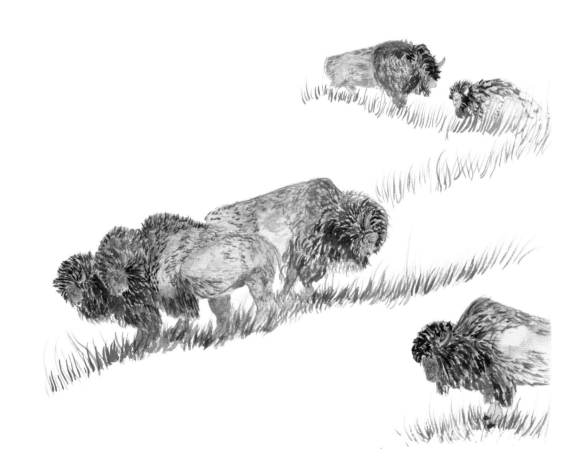

Home On The Range

Dr. Brewster M. Higley

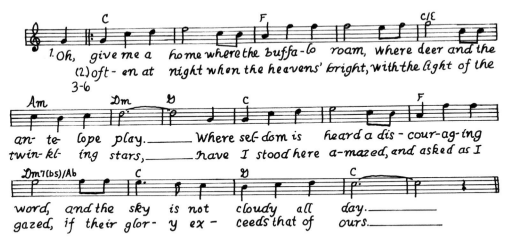

1. Oh, give me a home where the buffa-lo roam, where deer and the
(2) oft-en at night when the heavens' bright, with the light of the
3-6
an-te-lope play._____ Where sel-dom is heard a dis-cour-ag-ing
twin-kl-ing stars,_____ have I stood here a-mazed, and asked as I
word, and the sky is not cloudy all day._____
gazed, if their glor-y ex-ceeds that of ours._____

3. Oh! Give me a land where the bright diamond sand
 throws its light from the glittering streams,
 Where glideth along the graceful white swan,
 Like the maid in her heavenly dreams.

4. Oh! Give me a gale of the Solomon vale,
 Where the life streams with buoyancy flow,
 on the banks of the beaver, where seldom if ever,
 any poisonous herbage doth grow.

5. Oh, I love the wild flowers in this bright land of ours,
 I love the wild curlew's shrill scream;
 the bluffs and white rocks, and antelope flocks
 that graze on the mountains so green.

6. Where the air is so pure and the breezes so fine,
 the zephyrs so balmy and light,
 that I would not exchange my home on the range
 forever in azures so bright.

"CAVE"

by Breathe Owl Breathe

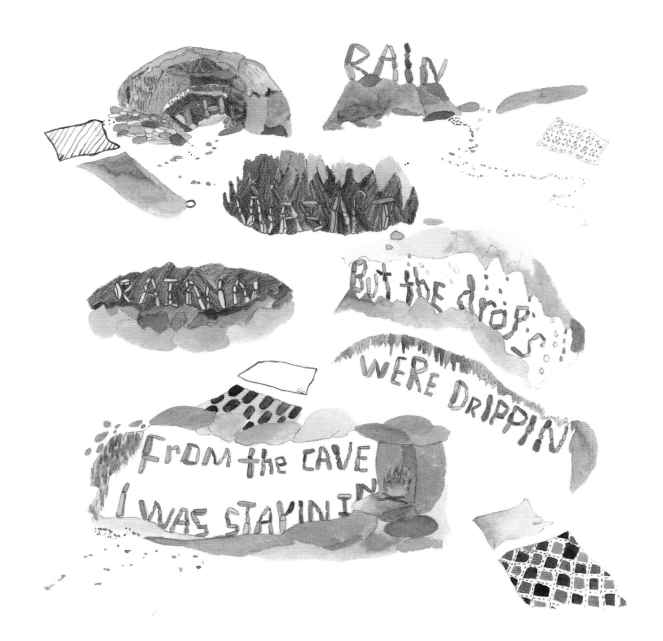

RAIN

RAININ

But the drops
WERE DRIPPIN'

FROM the CAVE
I WAS STAYIN IN

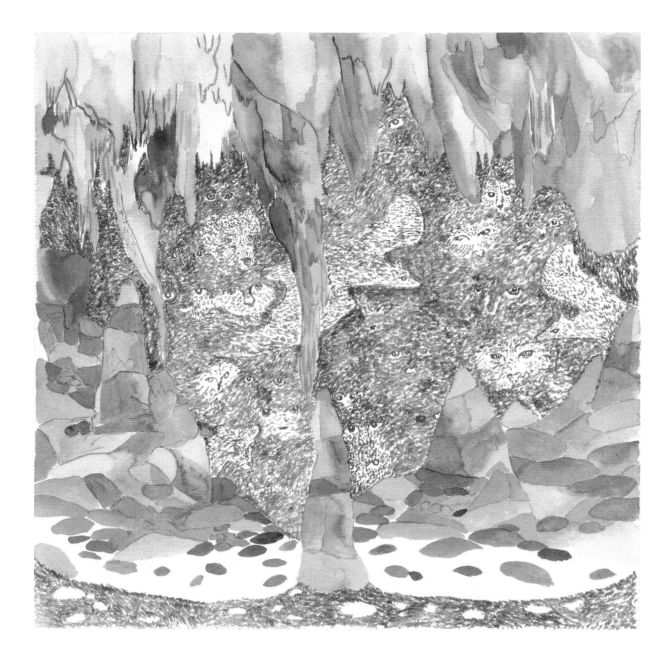

The rain
Wasn't rainin'
But the drops
Were drippin'
From the cave
I was stayin' in

I lit a lantern
And you were flattered
By the patterns
I had painted
And I said they were for you.

We stepped out
And the stars weren't shinin',
But the light
Was lightnin'
From over the hill.

Well the lightnin's got a question,
It's raising its hand,
While the thunder answers
"I'll do the best I can to call
 on you"
I'll call on you

Well if I didn't have the light
To light the sound
If I didn't have the sound
To sound the light,
Sound
All around

Well if I didn't have the light
To light the sound
If I didn't have the sound
To sound the light,
Sound
All around

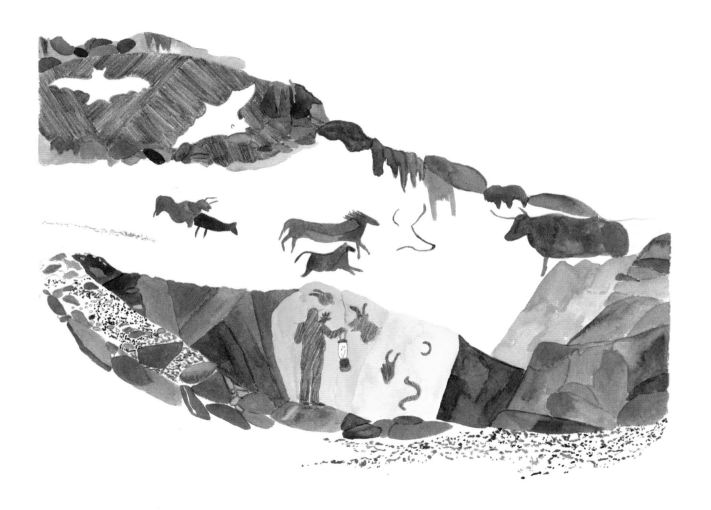

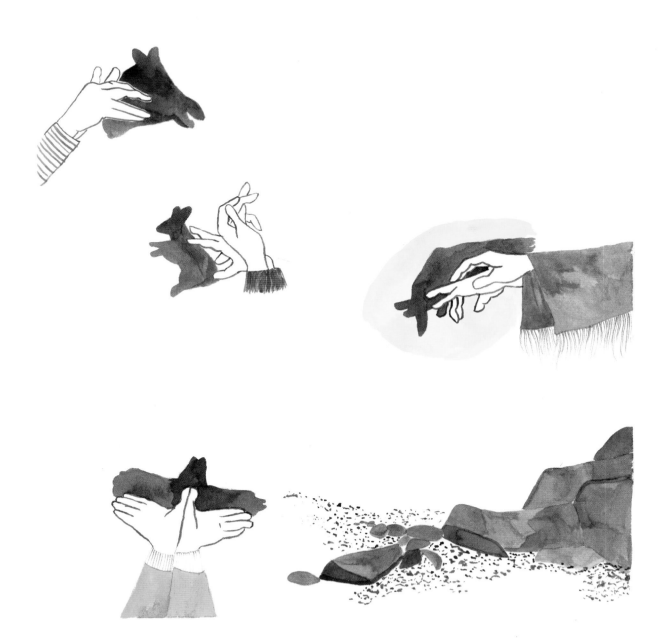

Cave
Breathe Owl Breathe

CAP 04

G G (2)
The rain wasn't rainin'

 G G(2) G G(2) G
But the drops were drippin' from the cave I was stayin' in

G G(6) G G G(6) G G
 G G
I lit a lantern and you were flattered by the patterns I had painted
and I said they were for you.

G G(2) G G G(6) G G G(6) G G
 G G(2)
We stepped out and the stars weren't shinin',

 G G(2)
but the light was lightnin' from over the hill.

G G(6) G G G(6) G G G(6) G G
 G
Well the lightnin's got a question, it's raising its hand,

 G(2)
While the thunder answers "I'll do the best I can to call on you"

G G(6) G G G(6) G G G(6) G G
 G(2)
 I'll call on you

 G
Well if I didn't have the light to light the sound

 G(2)
If I didn't have the sound to sound the light,

G G(6) G G G(6) G G G(6) G G G(2)
Sound all around

"FROGGIE WENT A COURTIN'"

Traditional Scottish folk song

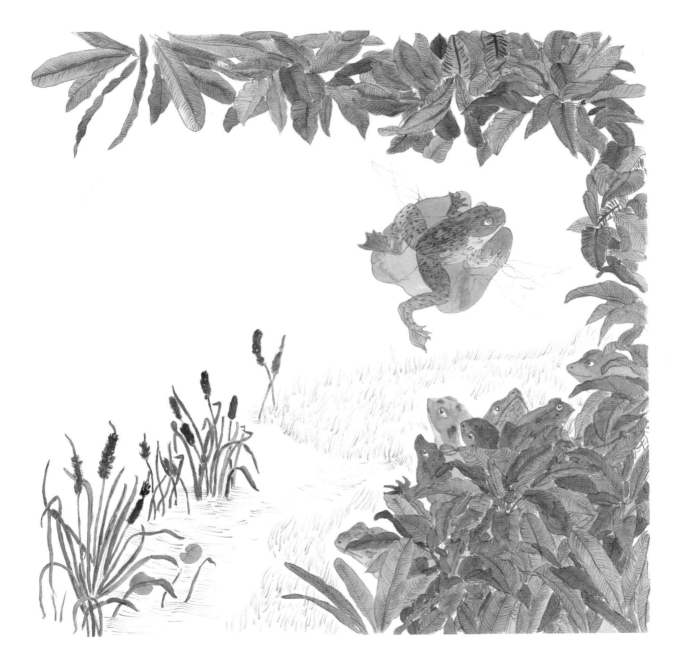

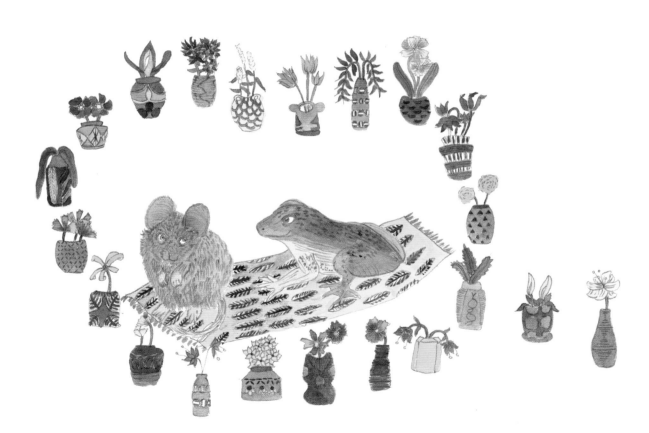

Oh, Froggie went a-courtin'
And he did ride, uh-huh,
Froggie went a-courtin'
And he did ride, uh-huh
Sword and pistol by his side,
uh-huh, uh-huh.

He rode up to Miss Mouse's door,
Where he had often been before.
He said, "Miss Mouse, are you within?"
"Yes, kind sir, I sit and spin."

He took Miss Mouse upon his knee
And said, "Miss Mouse, will you marry me?"
"Without my Uncle Rat's consent,
I wouldn't marry the president."

Uncle Rat laughed and shook his fat sides
to think his niece would be a bride.

When Uncle Rat gave his consent,
the weasel wrote the publishment.
"Where will the wedding supper be?"
"Way down yonder in a hollow tree."

"What will the wedding supper be?"
"A few green beans and a black-eyed pea."

First to come was a bumblebee.
He danced a jig with a crooked backed flea.

The owl did hoot,
The birds they sang,
And through the wood,
the music rang.

They all went sailing 'cross the lake,
And got swallowed up by a big old snake.

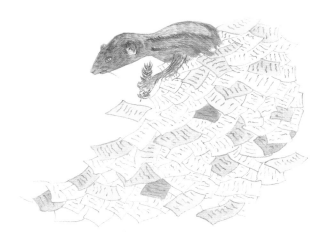

113

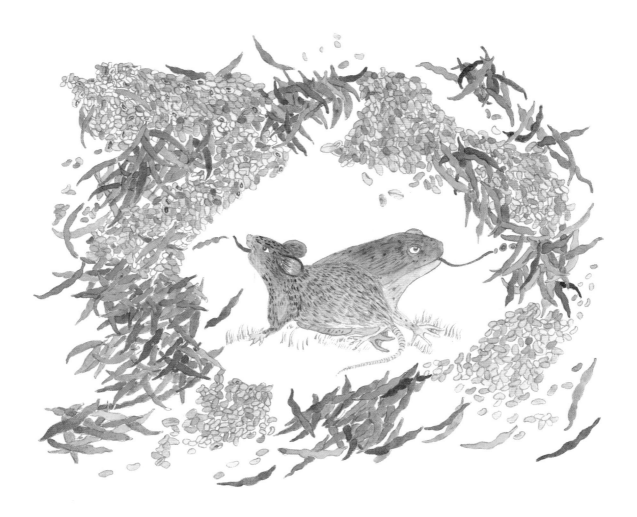

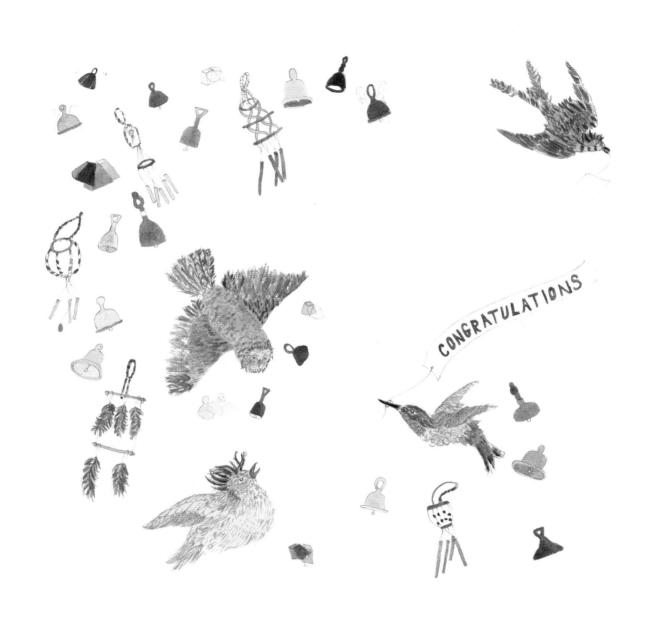

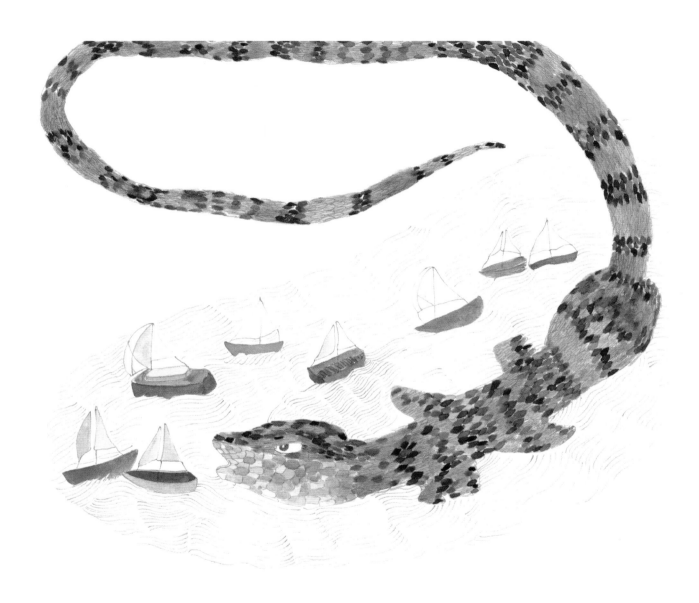

Froggie Went A-Courtin'

Traditional Scottish folk song

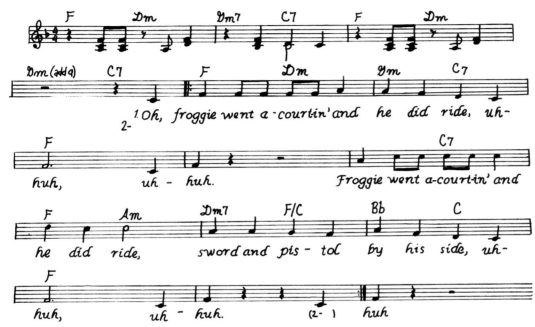

1. Oh, froggie went a-courtin' and he did ride, uh-huh, uh-huh. Froggie went a-courtin' and he did ride, sword and pis-tol by his side, uh-huh, uh-huh. (2-) huh

2. He rode up to Miss Mouse's door,
where he had often been before,

3. He said, "Miss Mouse, are you within?"
"Yes, kind sir, I sit and spin."

4. He took Miss Mouse upon his knee
and said, "Miss Mouse, will you marry me?"

5. "Without my Uncle Rat's consent,
I wouldn't marry the president."

6. Uncle Rat laughed and shook his fat sides
to think his niece would be a bride.

7. When Uncle Rat gave his consent,
the weasel wrote the publishment

8. "Where will the wedding supper be?"
"Way down yonder in a hollow tree."

9. "What will the wedding supper be?"
"A few green beans and a black-eyed pea."

10. First to come was a bumblebee.
He danced a jig with a crooked backed flea.

11. The owl did hoot, the birds they sang
And through the wood the music rang

12. They all went sailing 'cross the lake,
and got swallowed up by a big old snake.

"THE LITTLEST BIRDS"

by Samantha Parton and Jolie Holland

Well I feel like an old hobo
I'm sad, lonesome and blue
I was fair as a summer's day
Now the summer days are through
You pass through places
And places pass through you
But you carry them with you
On the soles of your traveling shoes

Well, I love you so dearly
I love you so dearly
I wake you up in the mornin'
so early just to tell you
I got the wanderin' blues
I got the wanderin' blues
And I'm gonna quit these rambling ways
One of these days soon

And I'll sing
The littlest birds sing the prettiest songs
The littlest birds sing the prettiest songs
The littlest birds sing the prettiest songs
And the littlest birds sing the prettiest songs

Well it's times like these I feel so small
And wild like the ramblin' footsteps
of a wanderin' child
And I'm lonesome as a lonesome whippoorwill
Singin' these blues with a warble and a trill
But I'm not too blue to fly
No, I'm not too blue to fly

'Cause the littlest birds sing the prettiest songs
The littlest birds sing the prettiest songs
The littlest birds sing the prettiest songs
And the littlest birds sing the prettiest songs

Well I love you so dearly
I love you so fearlessly
I wake you up in the mornin'
so early just to tell you
I got the wanderin' blues
I got the wanderin' blues
And I don't want to leave you
I love you through and through

Well I left my baby on a pretty blue train
I sang my songs to the cold and the rain
And I had the wanderin' blues
And I sang those wanderin' blues
And I'm gonna quit these ramblin' ways
one of these days soon

And I sing
The littlest birds sing the prettiest songs
The littlest birds sing the prettiest songs
The littlest birds sing the prettiest songs
And the littlest birds sing the prettiest songs

121

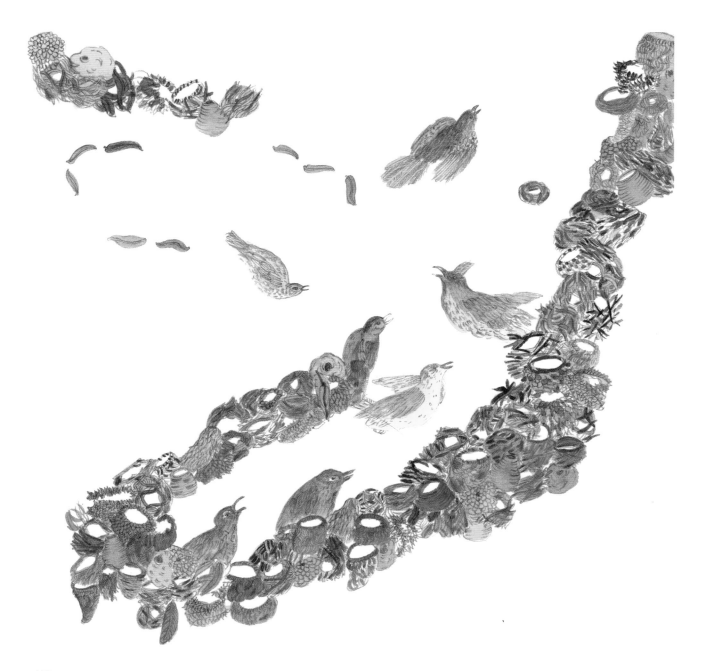

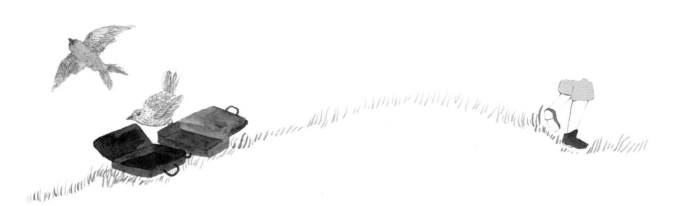

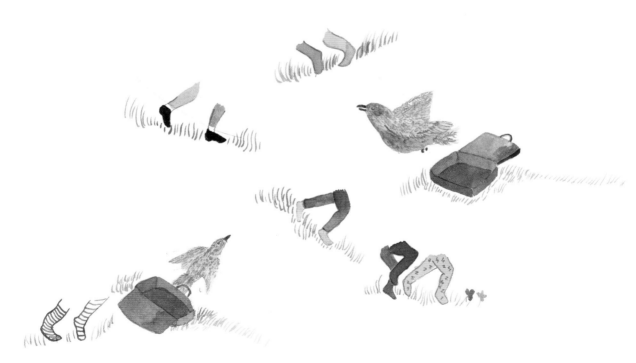

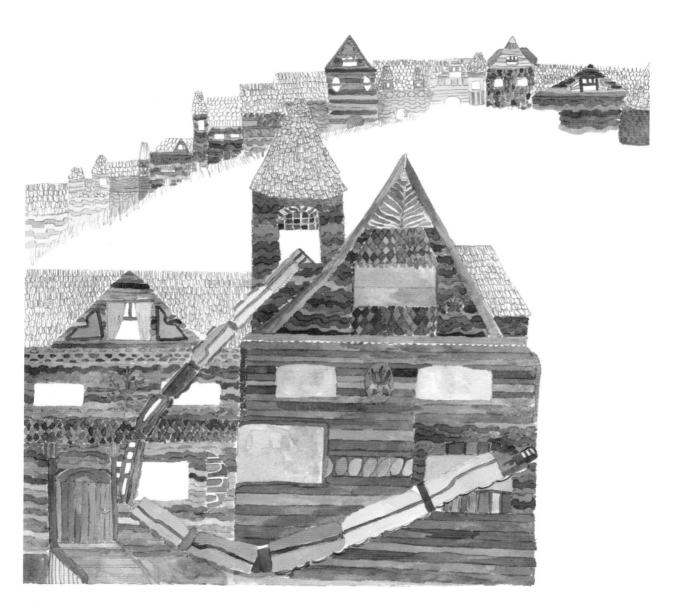

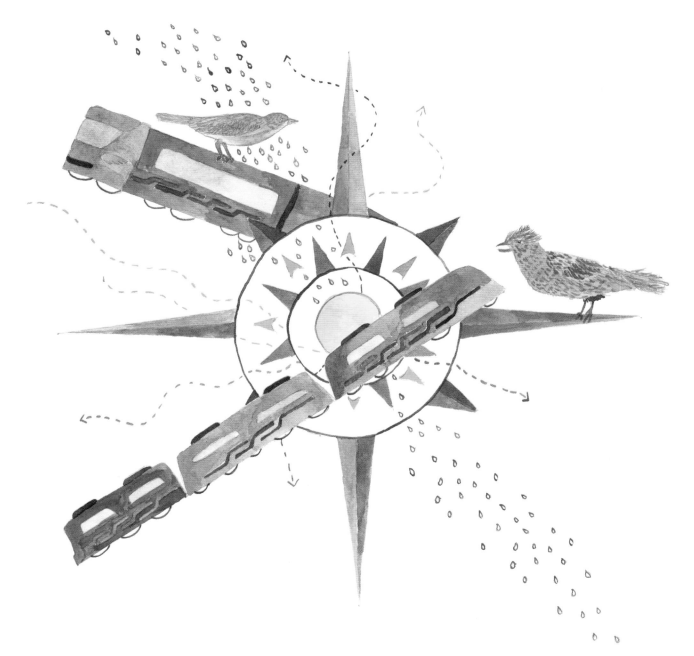

The Littlest Birds
Samantha Parton and Jolie Holland

 C F G C
Well I feel like an old hobo. I'm sad, lonesome and blue.

 C G
I was fair as a summers day, now those summer days are through.

 F C G
You pass through places and places pass through you

 F C G C F C G C
But you carry them with you on the soles of your travelin' shoes

F C G C F C G
 C F C G
Well, I love you so dearly. I love you so dearly.

 C F C G C
I wake you up in the mornin' so early just to tell you

 F C G C F
I got the wanderin' blues. I got the wanderin' blues

 C F C G C F C
And I'm gonna quit these ramblin' ways one of these days soon

 G C F C G C
(chorus) And I'll sing

 F C G
the littlest birds sing the prettiest songs (x4)

F C G C F C G C F C G C F C G
 C F C G C F C G C
Well its times like these I feel so small & wild like the ramblin' footsteps of a wanderin' child

F C G C F C C
And I'm lonesome as a lonesome whippoorwill singin' these blues with a warble & a trill.

F C G C F C G C
But I'm not too blue to fly, no I'm not too blue to fly

 F C G G C
'Cause the littlest birds sing the prettiest songs (x4)

F C G C F C G (x6) C F C G
 C F G
Well I love you so dearly. I love you so fearlessly

C F C G C
I wake you up in the mornin' so early just to tell you

 F G C F C
I got the wanderin' blues, I got the wanderin' blues

 C F C G C F C G
And I don't want to leave you. I love you through and through.

C C F C C F C G
Well I left my baby on a pretty blue train & I sang my songs to the cold & the rain

C F C G C F C G
And I had the wanderin' blues. And I sang those wanderin' blues

 C F G C F C
And I'm gonna quit these ramblin' ways one of these days soon

 G C F C G C F C G
And I sing, the littlest birds sing the prettiest songs (x6)

ACKNOWLEDGMENTS

Thank you to my family, Lucas and Coyote, for the immense emotional support throughout the entire process of this project, from its conception to its completion.

Thank you to the authors and musicians of all the songs that were the inspiration for this body of drawings. I am eternally grateful.

Lastly, thank you to everyone at Chronicle Books for granting me the special opportunity in making this book happen!

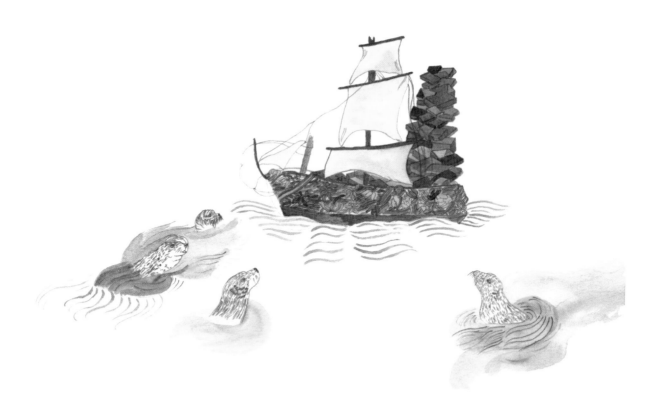